ACTIVE SIGHTS

Art as Social Interaction

ACTIVE SIGHTS
Art as Social Interaction

Timothy Van Laar
*University of Illinois
at Urbana-Champaign*

Leonard Diepeveen
Dalhousie University

MAYFIELD PUBLISHING COMPANY
Mountain View, California
London • Toronto

Copyright © 1998 by Mayfield Publishing Company

Library of Congress Cataloging-in-Publication Data
Van Laar, Timothy
 Active sights : art as social interaction / Timothy Van Laar,
Leonard Diepeveen.
 p. cm.
 Includes bibliographical references and index.
 ISBN 1-55934-929-8
 1. Art and society—History—20th century. 2. Artists—
Psychology. I. Diepeveen, Leonard. II. Title.
N72.S6V36 1997
701' . 1 ' 0309045—dc21 97–9856
 CIP

Manufactured in the United States of America
10 9 8 7 6 5 4 3 2 1

Mayfield Publishing Company
1280 Villa Street
Mountain View, California 94041

Sponsoring editor, Janet M. Beatty; *production editor,* Carla L.White;
manuscript editor, Anne Montague; *text and cover designer,* Susan Breitbard;
cover art, Rachel Whiteread; *cover photo,* Edward Woodman; *manufacturing
manager,* Randy Hurst. The text was set in 10/13 Sabon and printed on 50#
Finch Opaque by Malloy Lithographing, Inc.

Preface

This book was written to provide a framework for discussing the complex interactions among an artwork, the artist, and an audience. An understanding of these interactions is central to the study of art because art is a social activity and its images, objects, ideas, and events find their meaning in the complicated dynamics of this relationship. Most art texts do not address these issues, leaving them to ad hoc discussions in the classroom and studio. But these are precisely the issues that clarify the current state of the art world. For students of twentieth-century art and studio artists in particular, an understanding of art's social interaction is extremely relevant to, perhaps at the heart of, their education and work. And, of course, such issues are of interest to the general reader who wants insight into the often bewildering diversity of contemporary art.

Active Sights is a specific, applied examination of the relationship between art, artists, and viewers, and we assume that students in contemporary art courses and senior seminars in studio art are those to whom these interactions are most immediate and important. Not that students in other courses—art appreciation, for example—would not find these issues interesting, but we have assumed that the readers of this book have a basic knowledge of art history and contemporary art. We use examples from throughout the late nineteenth and twentieth centuries in order to illustrate that these issues are both recurring (that is, Henri Matisse and Ann Hamilton belong in the same world) and current. We argue that a major reason today's art world is so torn with controversy is that these issues are poorly understood. *Active Sights* makes use of art history and critical theory to elucidate concerns peculiar to people involved in contemporary art.

In the first chapter, we posit the need for a systematic study of art's social functions and outline the problems associated with their neglect. The book in general argues that artists and their audience need to examine many of the things they take for granted; the first chapter in particular uses an extended example to look at the conflicting assumptions that typically insert themselves into critiques of art, and

uses that examination to argue for the necessity of a study of art's social functions, which the rest of the book engages in.

Chapter 2 considers the belief systems that artworks interact with. In doing so, the chapter demonstrates how presuppositions about matters other than art (such as political philosophy and sexual identity) affect the making and interpreting of art. Belief systems, with all their messiness and contradictions, are more capable of accounting for the production and functions of art than are art "theories."

Chapter 3 takes a look at the social roles that characterize how artists function in society. It presents a series of historical paradigms (such as the artist as entrepreneur; the artist as social critic) to demonstrate how these models can describe some of the tensions in today's art world, and how they each require their own criteria for discussion and evaluation.

Chapter 4 examines the varieties of artist–audience relationships. It does so in order to discuss how audiences (in addition to artists) shape the social function of artworks, and how this relationship takes various recurring forms in Western art.

The final chapter underscores how this book has argued that people make art by being connected to society. It focuses the book's central issues by examining in detail a single work, the "perfect picture" created by Komar and Melamid.

ACKNOWLEDGMENTS

We would like to thank our friends and colleagues for reading and commenting on the manuscript in its various stages: Cliff Christians, Mark Salmon, George Dimock, John Walford, Joel Sheesley, and Ted Prescott. We would also like to thank several people who used early versions of the manuscript with their students and offered us their comments and advice: Loren Baker, John Bakker, and especially David Klamen.

The School of Art and Design of the University of Illinois at Urbana-Champaign has been very supportive and helpful. We would like to thank Buzz Spector, Jonathan Fineberg, Barbara Kendrick, Bill Carlson, Darlene Schantz, and especially Theodore Zernich, director of the art school, who gave us full use of the school's resources. A special thanks to Leslie Brothers of the Krannert Art Museum and to Beth Almanza, also of the Krannert, who efficiently managed the permissions work. The English Department at the University of Illinois deserves our gratitude for providing Len Diepeveen with office space during the academic year 1993–94. In the early stages of this project, Dalhousie University provided a useful Research Development Fund grant. And thanks to Chris Quinn and David Ahola of the University of Illinois Ricker Library for their patient help.

We would also like to thank those who read the manuscript for Mayfield Publishing Company: Kenneth Bendiner, University of Wisconsin—Milwaukee;

Paul E. Ivey, University of Arizona; Clifton C. Olds, Bowdoin College; Dawn Perlmutter, Cheyney University; Jean Robertson, Herron Shcool of Art, IUPUI; Kristine Stiles, Duke University; Jan Newstrom Thompson, San Jose State University; Jay Williams, University of South Carolina; and Josephine Withers, University of Maryland. Anne Montague was a superb copyeditor. We are also in debt to Marty Granahan, Rights and Permissions Editor; Carla White, Production Editor; and Pam Lucas, Editorial Assistant, for their help and patience. The advice, good sense, and congeniality of Jan Beatty, our Sponsoring Editor, have made this project a pleasure. Finally, we would like to thank our extended families, who at family reunions let us disappear so we could work.

Contents

To Karen and Susan

ACTIVE SIGHTS
Art as Social Interaction

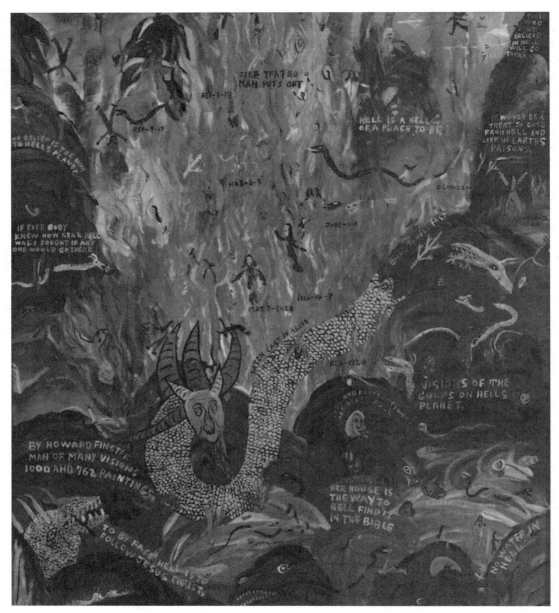

Figure 1.1 Howard Finster, *Hell Is a Hell of a Place* #2272, 1982. (Courtesy of Phyllis Kind Gallery, N.Y. and with permission of the artist.)

Introduction

The Picture Doctor, the Passionate Guru, and the Pluralist Albatross

> *In the midst of our discussion one of the students walked up to me and said, "Mr. Shahn, I didn't come here to learn philosophy. I just want to learn* how *to paint."*
> —Ben Shahn, *The Shape of Content*

The Reverend Howard Finster of Summerville, Georgia, tells the following story of his decision in 1976, at the age of sixty, to be an artist: "And one day I was workin' on a patch job on a bicycle, and I was rubbin' some white paint on that patch with this finger here, and I looked at the round tip o' my finger, and there was a human face on it. I could see it plain as day. And right then a warm feelin' come over my body, and a voice spoke to me and said 'Paint sacred art.'" For Finster, a Baptist minister who recognized that voice as the voice of God, sacred art has been the equivalent of preaching, and preaching volubly: more than ten thousand works, on everything from canvas to Masonite to muffin tins and gourds. All his works are textual, assertive sermons in paint (Figure 1.1). Finster claims: "Ever' one o' my paintings talks to people. Ever' one o' my paintings has a religious message. Ever' one o' my paintings is a sermon, just like the sermons I used to preach in these churches around here. And when people take one o' my paintings to their house, them messages stays with 'em, and they remember 'em."[1] In the process, he has gained a spectacular international reputation, appearing in numerous solo shows in New York, Chicago, and internationally, in the 1984 Venice Biennale, and on album covers for Talking Heads and R.E.M.

A review in *Artforum* magazine of his 1990 show at the PaineWebber Gallery makes the following comment on his work: "As the membrane that separates the subversive, subcultural, antisocial impulse from the organized social body dissolves, the potency of antagonistic, escapist, or psychologically obsessive alien elements beneath our culture's self-perpetuating veneer of health, normalcy and well-being is inevitably reduced."[2]

One of the myths about art is that it is separate from ordinary human activity. Art, the story goes, is an object of contemplation, serenely situated within the sheltering walls of the museum or gallery. Having checked their bags and umbrellas at the door, people walk slowly by artworks, and talk in a whisper. Artworks are things that do not have a function, except, perhaps, to give aesthetic pleasure.

In reality, art does all kinds of things, and people don't always walk by it very quietly. Consider Richard Serra's *Tilted Arc,* for example. It began blandly enough, as a commission by the U.S. General Services Administration as part of its Art-in-Architecture program, and was installed in 1981 at Federal Plaza, New York City. *Tilted Arc,* designed to traverse the plaza, was a 12-foot-high-by-120-foot-long arc of 2$\frac{1}{2}$-inch-thick rusting Cor-ten steel (Figure 1.2). As is the case with most site-specific works, *Tilted Arc* was intended to get people to interact with it, as part of the work's location and function. As Serra explained:

> When I started working on the project for Federal Plaza I made extensive studies of it. The plaza was essentially used only as a place of transit through which people pass from street to building; therefore, *Tilted Arc* was built for the people who walk across the plaza, for the moving observer. *Tilted Arc* was constructed so as to engage the public in a dialogue that would enhance, both perceptually and conceptually, its relation to the entire plaza. The sculpture involves the reader rationally and emotionally. A multitude of readings is possible.[3]

As Serra predicted, people got involved with the work, but they wanted to do something different from what Serra had in mind. Serra saw himself as a social critic. As he claimed in an interview in 1980, "I've found a way to dislocate or alter the decorative function of the plaza and actively bring people into the sculpture's context. . . . After the piece is created, the space will be understood primarily as a function of the sculpture."[4] His audience, however, didn't want a social critic; they had another idea of what the artist of the oppressive, windswept Federal Plaza should be. An organized protest began to gather steam, culminating in a public hearing in the spring of 1985, attended by many art world celebrities: Rosalind Krauss, William Rubin, Donald Judd, Frank Stella. (Apparently Serra was shocked by the public turmoil, despite his wish as social critic to transform the square.)

While the politics of the inquiry were questionable at best, the principles underlying the debate were legitimate, and based on differing roles imagined for the

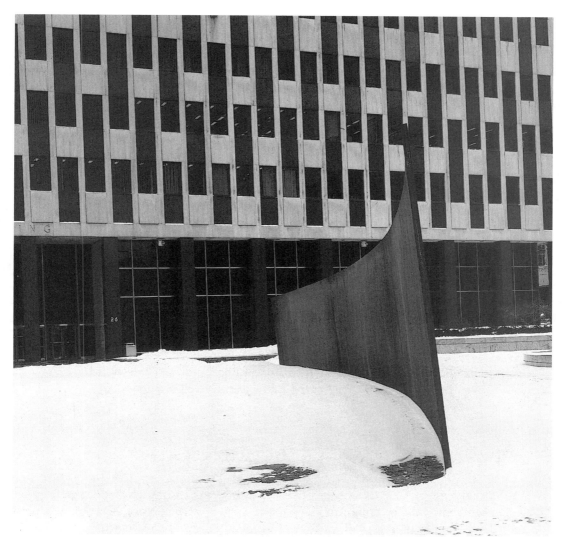

Figure 1.2 Richard Serra, *Tilted Arc,* 1981. Cor-ten steel, 12' × 120'. Federal Plaza, New York City. (© Richard Serra/Artists Rights Society [ARS], New York.)

audience and the artwork. There were two basic objections to the piece: (1) The rights and opinions of the people who used the plaza had been ignored. (2) Had they been consulted, they would have said the primary reason they hurried *through* the plaza was primarily because it was an uncomfortable, authoritarian place—and *Tilted Arc* made it more so. As the critic Patricia Phillips was to summarize in *Artforum,* the sculpture was as dehumanizing as the totalitarian environment it attacked. Everyone crossing the plaza had to deal with the angle of the piece, and the way it disrupted their movement.

Serra and his defenders argued several points: They argued the classic one that uncomfortable art eventually becomes great art. They praised the work's aesthetic values as a deliberately uncomfortable reorganizing of the plaza's space. They argued that such a site-specific work could not be removed to a new site, and that removal would constitute destruction. They argued on the basis of free speech, and they argued that the artist has rights to his work after it is sold. This complicated argument, presenting very differing views of the functioning of art, meant that the terms of one side of the conflict did not often address those of the other. *People* magazine of April 1, 1985, got it wrong in its headline: "A Rusty Eyesore or a Work of Art?" *People's* criteria were formalist, based on what the work *looked* like, but the debate wasn't within formalism, it was between two attitudes toward art's social interaction.

But the clash did end. After three days of public hearings, a GSA panel recommended on April 10, 1985, that the work be removed. On March 15, 1989, after several further legal battles, *Tilted Arc* was destroyed.

ART'S SOCIAL DIVERSITY

The diversity of art has more often been a source of irritation than of celebration. More specifically, failure to recognize the often contradictory varieties of activity called art creates myriad problems in communication between artist and audience and among artists. For example, this failure contributes to the recurring National Endowment for the Arts controversies. For some people, to support artists means to support the makers of beautiful objects, objects that enhance our environment. They perhaps imagine groups of artists serving the community with their well-honed skills, their eye for beauty, their endlessly novel and original inventions. But for others, the artist's role is one of confrontation. The artist is called to an eternal struggle to transform the world, often by first revealing what he or she thinks the world really is. So some people want Calder's elegant, whimsical *La Grande Vitesse* (Figure 1.3), and others want Serra's *Tilted Arc*. Some artists seek to delight and entertain, others to disturb and confront. Such intentions are part of very different artistic roles and belief systems. These two examples only hint at the diversity avail-

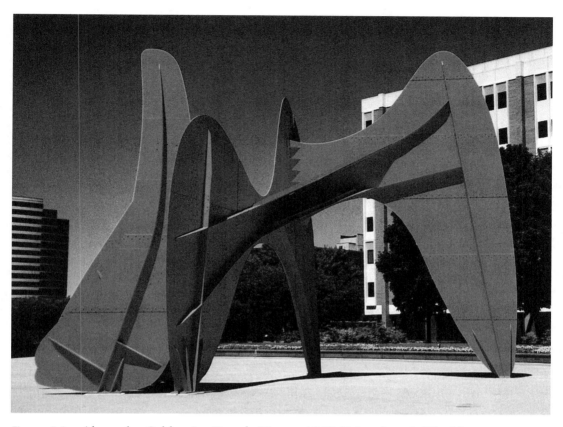

Figure 1.3 Alexander Calder, *La Grande Vitesse,* 1969. Painted steel 47' wide. Calder Plaza, Vandenberg Center, Grand Rapids, Michigan. (© 1997 Artists Rights Society [ARS], New York/ADAGP, Paris.)

able to artists and audiences, and it is no wonder that there is general bewilderment about what artists do, a bewilderment that easily degenerates into hostility.

These controversies remain controversies partly because the argument is on the wrong level: *works* of art are challenged when, instead, the social roles and belief systems that created these works should be made explicit and critiqued. The result of this failure to clarify art's functions is unfortunate, for it encourages a tendency to see art as a monolithic social category, to overgeneralize, or to waste time creating hierarchies like the old art–craft distinction. When art is seen as a monolithic social category, all artists are assumed to be engaged in the same general activity. Any deviation from the accepted practice creates cultural dissonance, and comments of the following sort: "These people call themselves artists, but what they do doesn't look like art." Such an attitude, for example, underlies responses to the first major exhibition of modern art in the United States, the 1913 Armory Show. Reaction to the show's avant-garde work was explosive. Concerning the paintings of Odilon Redon and Matthijs Maris, a major reviewer wrote:

> Odilon Redon is a dreamer in lines as Maris is a dreamer in colors. Both are poets if you will, but neither is a draughtsman or a painter. Their absorption in the subjective vision has prevented their acquiring a sound and definite method of expression.[5]

Such limited definitions of art are still a part of current discussions. They underlie many of the ideological logjams in the debates over Richard Serra's *Tilted Arc,* the 1984 show on primitivism at New York's Museum of Modern Art (MoMA), and the art of Matthew Barney, who in the early 1990s used a hydraulic jack to coat his torso with Vaseline and then swung nude across the walls and ceiling of a Los Angeles gallery.

A semantic problem is partly to blame here. Artists, critics, and the public simply use the general words *art* and *artist* too often and for too many things. That carelessness is revealing, for one can tell a lot about a person's relationship to a thing by the sort of name that person gives it. For example, a two-year-old, pointing to an oak tree, will call it a tree. Many adults look at it and call it an oak. But Bill VanderWeit, chief forester for the city of Champaign, Illinois, looks at that same tree and calls it a Silver Siberian Oak (or something like that). The general point this illustrates is not sensational: Specialized interests produce specialized vocabularies and categories with a lot of differentiating details. But it does illustrate something important in its particular application in the visual arts. Not just the general public but the art community itself tends to use the word *art* for every social category of, well, art, differentiating only by materials—painting, ceramics, photography—and not by social function. Thus as a consequence, perhaps, of the dominance of formalist concepts in art theory, artists have directed their specifics about art to materials and not toward art's function. In a matter as basic as vocabulary, artists need to be much more specific in their description of their various social activities.

But when art *is* differentiated by its social function, this differentiation is usually used to create a category that is structured hierarchically, rather than by value-free distinctions; in effect, to declare some activities more "art" than others. The art–craft distinction is the most notorious example. The fine art–popular art distinction is another. As recently as 1979, the critic Richard Hennessy argued in *Artforum* that photography is not fine art, and therefore it is a lesser art form. Arguing from the assumption that artworks must be tactile objects, he concludes that "photography lies at the bottom of the visual food chain."[6] In these examples, the goal is still a single, albeit smaller and more purified, category called art. We have merely chipped away at the monolith.

The truth is, people call many extremely different social activities "art." And then they put all of these activities in the same school or have them all funded by the same grant agencies. Jenny Holzer makes electronic sign installations, such as *Truisms, 1977–79,* which lit up a Times Square billboard, unsettling taxi drivers and theatergoers with such enigmatic phrases as "ABUSE OF POWER COMES AS NO SUR-PRISE" (Figure 1.4). Lucian Freud paints such fleshy works as *Self-portrait* with a tactile skin of thick oil paint (Figure 1.5). The appearance and function of Holzer's and Freud's work seem to have nothing in common except that the institution of high art claims them both. This claim is usually thought to rest on their shared history within the tradition of Western high art. But the more one thinks about it, the more baffling it is. What shared history? What does Jenny Holzer have to do with Lucian Freud?

The concepts underlying questions like these should be important issues. They should be important because different assumptions about art's function demand different criteria for discussion and evaluation. For example, it is generally accepted that European and American formalist theories are irrelevant to forming an understanding of tribal art, that the work cannot be judged apart from its social function, hence the 1984 controversy over the Museum of Modern Art's exhibition "'Primitivism' in 20th-Century Art: Affinity of the Tribal and the Modern" (we discuss this show in Chapter 4). Just as critics spar over the appropriateness of white gallery walls as the setting for tribal masks juxtaposed with modernist paintings, artists also lack unity, for they have as dissonant a variety of artworks and functions. For example, some artists want to "transform society," while others want to "investigate the formal properties of color," "celebrate nature," or "express themselves." Once one has examined the underlying motivation, one can begin to understand the social function of the work and formulate criteria for evaluation.

Works of art, then, do many things. "Do," of course, vaguely describes a work's actions. A work can "do" myriad things: It can contrast lights and darks, decorate a wall, or use color and texture to create visual rhythm. But it can also challenge a social class, assault its audience, confirm a group's beliefs, reveal its maker, issue a personal statement, or hide its meaning. All these activities, including the formal ones, imply a future social context that the artist in some ways anticipates as she makes her work. This book suggests that the best way one can under-

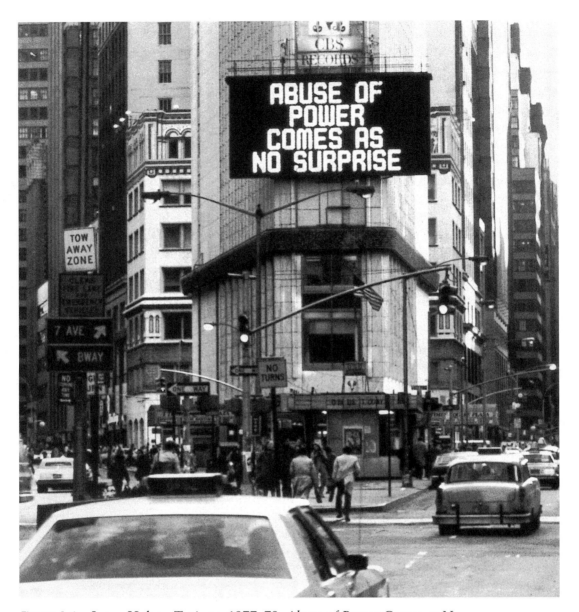

Figure 1.4 Jenny Holzer, *Truisms, 1977–79: Abuse of Power Comes as No Surprise,* 1982. Spectacolor Board No. 1, Times Square, New York. (© Jenny Holzer, sponsored by the Public Art Fund. Photo by Lisa Kakane. Courtesy of Barbara Gladstone Gallery.)

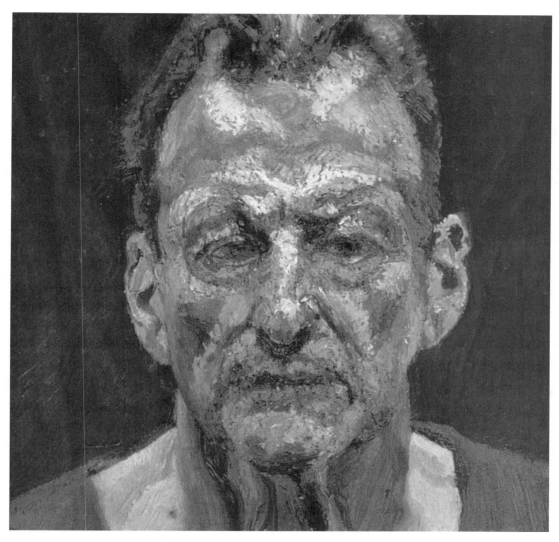

Figure 1.5 Lucian Freud, *Self-portrait*, 1990–1991. Oil on canvas, 12" × 12".

stand, produce, and critique art is by paying attention to what a work does: the beliefs it embodies, the social roles it assumes, and its interactions with its audience.

AN EXAMPLE FROM ACADEMIA

The difficulty of attaining such understanding is manifest in all of art's institutions: in government programs, in museums, in art galleries, in the art press, and in art schools. For example, consider *Jacob and the Angel,* painted by the artist Rick Beerhorst when he was a student (Figure 1.6), and imagine the following critique by a group of instructors who are themselves practicing artists.

Instructor A appreciates the "composition" of the painting. She enjoys the spatial divisions of the work and how these divisions create a pressure from the surroundings on the figures. But she considers the use of so much black in the palette to be a mistake—it deadens the light. Troubled by the naive figure drawing, the poor attention to anatomy, she asks a good question: How can an upper-level painting student honestly adopt a naive style? Her conclusion about the work is that technical ineptitude creates a barrier to effective communication.

Instructor B quarrels with this assessment. He is stirred by the deep conviction of the painting, its emotional intensity, its rawness. But he is disturbed by its small scale, which he thinks does not do justice to the subject. Increasing the scale will let the student be more aggressive with paint. He tells the student to be more courageous and to take greater risks. And he asks a rhetorical question: How can an image so full of psychological tension and violent and sexual overtones be painted with such detachment and repression? The painting is too fussy. The image is too static; it needs to breathe or maybe explode!

Instructor C gently disagrees. He is attracted to the intimate scale of the work. He reflects on painting as autobiography, how every brushstroke is a signature and a record of private experience. He is unhappy that the image itself is so blatant; it needs mystery, ambiguity. The color and brushmarks should be more personal. The narrative subject matter should not be allowed to dominate, because it tends to make the painting merely an illustration. He wonders how a painting that suggests a spiritual struggle can be so heavy-handed. Fill the painting with more private experience, a more intimate sense of touch, he offers. Finally, using his favorite phrase, he tells the student to "love-up" the surface.

And finally, Instructor D speaks. Seeing the painting as a presentation of gender issues, she is intrigued by the way the male figure seems to be embracing the androgynous (or female?) angel, while the angel seems to be pulling the male figure apart. She wonders, is the image a representation of a struggle with sexual identity? In addition, she admires the environment of the two figures, an alienating urban space that suggests oppressive social constructions of sexuality. However, she wor-

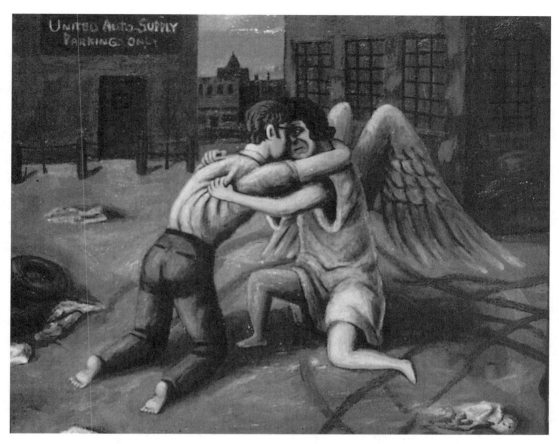

Figure 1.6 Rick Beerhorst, *Jacob and the Angel,* 1987. Oil on wood, 14" × 18". (© Richard H. Beerhorst)

ries that the religious allusion is distracting and that it narrows the scope of the painting. Get rid of the angel wings, she says; they cloud the issue.

These wildly diverse comments make little or no effort to address the student's intentions, the student's presuppositions about his content, or the work's social function and relation to its audience. Within the laissez-faire environment of the university, instructors' personal agendas conspire to allow them to neglect students' intentions. In their attempt to discuss ideas, these instructors impose idiosyncratic criteria, and the critique collapses into a mess of conflicting aesthetic views and ideologies. These incomplete and contradictory readings of an artwork redirect or re-create its content.

Stated with no reference to whether *Jacob and the Angel* is an adequate attempt to reach the artist's goals, each of these four redirections is merely an item on a menu, leaving the student with no basis for working with one instructor's comments rather than another's. Such redirections are also difficult to address because they are presented under the guise of critiquing the work, apart from its intended social function. Instructors A, B, and C start with the formal characteristics of the work: its scale, organization, and color. Instructor A is a "picture doctor" ready with prescriptions and formulas that derive from rational, "academic" analysis. Instructor B, the passionate guru, believes in the individual artwork as monument and the artist as hero. The one reference to "subject matter" in his critique was not meant in the conventional sense; for him, the artist's ego is the subject of every painting. And Instructor C wants an art of secret codes and mystic introspection. Instructor D seems to move in another direction. Less concerned with the formal aspects of the work, she directs her comments to the work's implied narrative. But the narrative she constructs sees the religious references as secondary because they don't fit neatly with her gendered construction of the work's meaning. For all four instructors, their various personal agendas have actually redirected the work, although all four use aspects of the work as a sanctifying liturgy.

Although they have different goals for Beerhorst's painting, these instructors have one thing in common: They all advocate their own ideas of content. On the face of it, this doesn't seem to be a bad thing. Conventional wisdom suggests that instructors are at their best when they teach their passions. According to this view, for example, those who believe that artworks should be intensely personal should teach that position strongly, and demand that students do personal work. In other words, instructors should speak out for their own agendas.

To be sure, such an approach also allows for a conscious examination of an artwork's content. However, such clearly defined promotion of specific values should be more the prerogative of the *student* than of the instructor. Whose work is it, anyway? Consider the aggressively political Malcolm X images by Sue Coe (see Figure 2.5). Suppose Coe as an undergraduate took a class from our introspective, mystical Instructor C and actually took her instructor's advice. The art community might have received the biography of Malcolm X as if done by the introspective abstractionist Mark Tobey. Or consider this description by Ben Shahn:

> Some years ago when the painter Max Beckmann died suddenly, I was
> asked to take over his class at the Brooklyn Museum School. I did so . . .
> reluc-tantly. On my first morning with the students, I looked over their work
> and it appeared to me that the most conspicuous fault in it was lack of
> thinking. There seemed to be no imaginative variety or resourcefulness. It
> was mostly just Beckmann.[7]

Shahn was an admirer of Beckmann's work, but not, apparently, of his teaching.
Dogmatic teaching, rather than being heroic, is lazy or egocentric, and is sometimes
an odd blend of laziness and egocentricity that could be found only in academia.

Further, a teaching method that promotes a single agenda often creates a kind
of discipleship, a discipleship with many of the dangers and submissions of a reli-
gious cult. Imagine instructors who think of art only as a means of confessing
intensely personal, private thoughts and experiences and who demand that their stu-
dents engage in rituals of self-exorcism. Such single-mindedness attracts students
who want clear answers and goals, students distressed by and lost in the diversity of
contemporary art. This sort of hierarchical relationship, while promising some a
cozy community of dependence, does not build the individual thinking one needs to
deal with the heterogeneity one will encounter outside the art school. It also
excludes those who have strong views of their own. (Of course, all sorts of other
dogmatic definitions of art—including a formalist position—can have this stifling
result.) A teaching method used to advocate and passionately impose a single agen-
da leads irresistibly to the instructor's adopting the role of guru, perhaps a guru who
believes that *all* art must at the very least breathe, if not explode.

The same process illustrated in this hypothetical but not atypical critique, a
process full of hidden agendas, is found in all the institutions of contemporary art:
reviewing in art magazines, curating in art museums, the grants procedures of gov-
ernment agencies, the selecting of artists by commercial galleries, and constitu-
tional amendments on the floor of the U.S. Senate. The problems surrounding the
critique of *Jacob and the Angel* mirror the problems in the art world: its conflicting
goals; its single, monolithic definitions of art; and its unquestioned assumptions.
Perhaps the most unsettling thing about the *Tilted Arc* controversy was that Serra
seemed surprised.

FORMALISM

During a time of more consensus in talking about art, Serra may have been less
surprised. For many artists and critics during the first two-thirds of the twentieth
century, formalism seemed to provide such a consensus. Formalism was the most
widely advocated approach to understanding art, especially in colleges and art
schools. It is a way of giving primacy to the formal elements of a work (line,

texture, shape, color) over questions of a work's social context (the artist's life, a work's original purpose, its external references). It would find the harsh brushwork of de Kooning's *Woman I* more interesting than the painting's possible misogyny. Strict formalism handles diversity by ignoring those aspects of an artwork that deal with function and intent. But in a world where Leon Golub paints violent images of mercenaries and interrogators while Jeff Koons exhibits floral puppies, a formalist approach is woefully inadequate. Indeed, this approach has limited appeal even for critiquing purely abstract art; it has even less use in the highly ideological, referential world where much contemporary painting and photography is to be found. Problems arise when formalist criticism is applied to art whose social functions overshadow purely formal criteria, such as the work of Barbara Kruger. Her untitled 1985 photo/collage that quotes the French filmmaker Jean-Luc Godard ("When I hear the word *culture* I take out my checkbook") demands not merely an analysis of its form but consideration of its textual source in Marxist film theory, and the economic and social values it challenges.

Furthermore, a purely formal discussion of an artwork typically focuses on a finished product; it does not look at all moments of the art-making process. These moments are essential; for some, they almost *are* the artwork. For example, the work of Bruce Nauman is rich in autobiographical reference, puns, and language, and talk about the process of making art is essential for getting at these three features. Regarding his 1966 *Wax Impression of the Knees of Five Famous Artists,* Nauman says:

> It's made of fiberglass, and they are my knees. I couldn't decide who to get for artists, so I used my own knees. Making the impressions of the knees in a wax block was a way of having a large rectangular solid with marks in it. I didn't want just to make marks in it, so I had to follow another kind of reasoning. It also had to do with trying to make the thing itself less important to look at. That is, you had to know what it is about, too.[8]

With its attention to the art *object,* formalism tends to ignore the art *process,* which after all is the core of art-making and the central feature of talk about art in art schools. Even the most formalist critics need to examine the art process in order to understand a work's use; they also need to consider its audience.

The paintings produced by Mark Rothko in his first major commission are a classic example of the awkward incompleteness of formalist analysis. Even though Rothko's work seems to epitomize formalist values, those values fall short: the work's context, process, and audience are essential to understanding the work. In 1958 Rothko was commissioned to create 550 square feet of murals to cover the walls of what was intended to be a fashionable restaurant in the new Seagram Building (designed by Mies van der Rohe) in New York. The purchase order Rothko received from Seagram's read "for decorations." After working for eight months on these pieces, Rothko, irritated with creating art for what he called "a place where

the richest bastards in New York will come to feed and show off," confided to an acquaintance, "I hope to paint something that will ruin the appetite of every son-of-a-bitch who ever eats in that room. If the restaurant would refuse to put up my murals, that would be the ultimate compliment. But they won't. People can stand anything these days." He painted a series of what have become his classic soft-edged, rectangular abstractions. Rothko's biographer reports that by the time Rothko finished the works and they were hanging in what indeed was an opulent restaurant, his malice had subsided: Spoiling the appetites of the richest bastards in New York was no longer as attractive, and "it had become clear that the people would taint his paintings." So within two years Rothko repaid the $35,000 commission and withdrew the murals, which a decade later were hung in a room of their own in London's Tate Gallery.[9] Rothko's classic work, with its austere formal oppositions, had as a primary motivating force several competing social functions: decoration, irritating rich bastards, and the formal one of aesthetic contemplation. The supposed formalist Rothko recognized the social consequences of artworks.

Awkwardly central to any discussion of the art process is the question of an artist's *intent* for a particular work. An artist's intentions can have different kinds and levels of authority. Artists sometimes have intentions they cannot articulate (Freudian, post-structuralist, and Marxist theorists of meaning are particularly interested in and adept at articulating these intentions). There are also works that can transcend their makers' original intentions, such as the photographs taken by the scientist Harold Edgerton of bullets penetrating apples and balloons, or the splatter of a drop of milk. Edgerton was interested in how the camera could freeze time through stroboscopic illumination. The results of his scientific studies have become influential artworks, exhibited in major art museums. (As we will see in Chapter 4, that transcendence of original intentions seems to be what the curators of the 1984 primitivism show at MoMA believed about the place of the "primitive" in modernism.)

Sometimes an artist's intentions for a work can seem spectacularly unreliable. It can happen that the audience's perception of an artwork is drastically different from what the artist intended. Such was the case with a work proposed by Barbara Kruger in 1989. The 30-by-218-foot mural was to cover a wall of the Los Angeles Museum of Contemporary Art's "Temporary-Contemporary" building. The text of the Pledge of Allegiance was to be printed in enormous letters on a red background. A border of blue would display short questions such as "Who follows orders? Who salutes longest?" Unfortunately, Kruger's proposed questions about who owns the pledge were not taken as ironic by the local community. The proposed mural faced the Little Tokyo neighborhood of Los Angeles, the heart of Japanese culture in Southern California. The local people interpreted it as an offensive reminder of their World War II internment and forced loyalty oaths, a new questioning of their allegiance. Kruger immediately modified the mural, removing the pledge.

This instability of intention has led some critics to question its usefulness. But even its instability can make artistic intention useful. Intentions are not authorita-

tive, but neither are they dispensable. While one could argue that the Reverend Howard Finster's purely theological intentions for his work are an incomplete way to address how the work actually functions, no one could claim that Finster's intentions are irrelevant. Intentions matter. They matter differently in different contexts: Intentions matter in art schools, where instructors have what looks like a moral obligation to *address* (which is not always the same as *accept*) their students' intentions. Intentions also matter, but in a different way, at almost every gallery opening, where an artist's statement of intent is neatly printed on the wall or in the catalogue, offering each viewer a contextual package with which to approach the works on view. Intentions matter where they are most inscrutable—for example, Jenny Holzer's Times Square electronic billboards.

In addition to muting the role of intention in art, formalism has had institutional effects. Formalism influences an institution such as the art school most notably in its curriculum. A typical American art school program offers undergraduate courses in such areas as figure drawing, watercolor, lithography, and bronze casting, but few—if any—in the politics or sociology of art, semiotics, or art theory. Even when the latter courses *are* offered, these topics need to be fully integrated into studio courses, where they bump against quite different agendas. Unfortunately, such topics as an artist's social role, conflicts of belief, or the artist–audience relationship are rarely mentioned when the problem at hand is to draw a foreshortened knee, control a color wash, grain a stone, or pour molten bronze properly.

This inadequate handling of issues that describe the meaning and social functions of artworks is unfortunate, especially since the signs of a postformalist age are everywhere. Highly political art fills our galleries, jostling for space with naive art and self-conscious, ironic postmodernism. Such artworks counter the late-formalist notion of technique as content, a notion resulting from, as one critic observes, "identifying image and content with materials."[10] As many critics have shown, even the late-1980s flirtation with formalism, the new abstractionism (or "neo-geo"), which revived the careers of some minimalists, had a historical, self-conscious reference that its predecessor lacked. Despite their many formal similarities, Peter Halley's 1989 *The Moment Passed* (Figure 1.7) is not just an imitation of the style of Piet Mondrian's 1930 *Composition (Blue, Red, and Yellow)*. Halley, insistent that his work not be abstract, incorporates into this and many other of his paintings a visual reference to high-tech circuitry, and uses that reference to comment on contemporary social organization. Halley refers to a part of the world that did not exist for Mondrian. This technological and representational bent calls attention to the six decades of art history that intervene between these two works. It is possible to simulate Mondrian's *Composition,* but not to duplicate it—Halley is playing with the possibilities of simulation. This complicated, multi-referenced context of Halley's work, only a small part of which might be called purely formalist, is the sort in which all artworks and artists function.

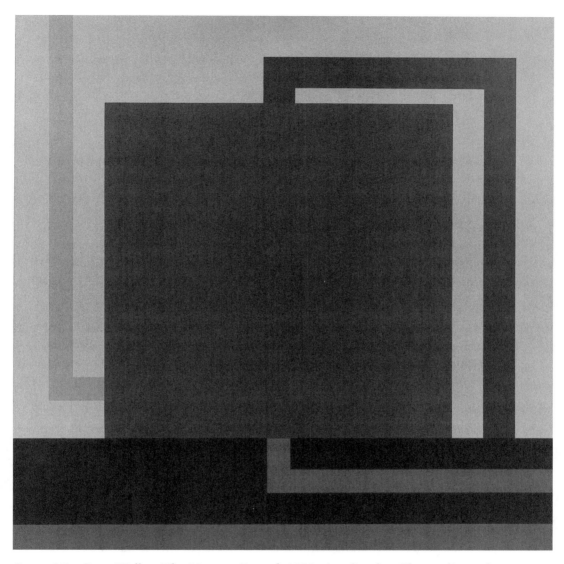

Figure 1.7 Peter Halley, *The Moment Passed,* 1989. Acrylic, day-Glo acrylic, and Roll-A-Tex on canvas, 97½" × 95". (Photo by Steven Sloman.)

PLURALISM

Other approaches to art have not had the kind of cultural dominance in the twentieth century that formalism has enjoyed. Feminism, Marxism, post-structuralism, and others have functioned, willingly or not, in a context of pluralism. In art criticism, pluralism is the belief that a defining characteristic of the art world is its diversity. This diversity arises from such things as the many belief systems out of which artists produce works, the multiple social roles artists take on, and the varied audiences they address. Usually, advocates of pluralism celebrate diversity: for them, difference is just plain *good*.

This promotion of pluralism makes many adherents to single approaches nervous. Like formalism, pluralism is in trouble these days—and from a wider body of critics. Critics as dissimilar as Allan Bloom and Hal Foster have shown that pluralism does not create freedom, but rather hangs like an albatross around the neck of contemporary society. While Bloom in *The Closing of the American Mind* (1987) argued for a return to an imagined Western educational Golden Age, and Foster in *Recodings: Art, Spectacle, Cultural Politics* (1985) argued for clear ideological commitments, both claimed that pluralism produces paralysis. According to them, our culture in general, confronted with all kinds of ideologies, considers differences between ideologies unresolvable and unimportant. Foster has attacked pluralism in the art world as leading "not to a sharpened awareness of difference (social, sexual, artistic, etc.) but to a stagnant condition of indiscrimination—not to resistance but to retrenchment." Foster's criticism also zeroes in on the problem with much higher education. Although in the critique of *Jacob and the Angel* the comments by instructors A, B, C, and D may be helpful and address legitimate concerns, all they immediately do is provide a smorgasbord of opinion based on the instructors' hidden assumptions and personal prejudices (sometimes referred to as "taste"). According to Foster, pluralism, with its wishy-washy relativism and indifference to principle, results in an art that becomes, as he says, just "one more curiosity, souvenir, commodity among others."[11] Such an environment stifles serious discussion of art.

Foster's criticism is useful, but it does not acknowledge that the diversity that accompanies pluralism is a fact—and it's not likely to disappear. Pluralism exists even within narrowly defined communities which, because of their commitment to the political consequences of their ideology, are most suspicious of pluralism. For example, two contradictory positions coexist within feminist art and art criticism. One emphasizes, even celebrates, difference from men; the other minimizes difference by arguing that gender roles are socially constructed.[12] Consider Judy Chicago, whose work (such as *Birth Project,* 1985) promotes a mythic femaleness, and Mary Kelly, whose work (such as *The Post-Partum Document,* 1973–79) analyzes the social construct of female roles. How would these two women effectively teach the same student without at least the student acknowledging some form of pluralism?

The extreme (and perhaps mythic) way that art schools have handled such contradictory positions is recounted by the abstract painter Al Held. Discussing his own teaching career from 1962 to 1980 at the Yale School of Art, Held recollects that there were

> egos in conflict with each other—no one was holding back. There were screaming arguments between the faculty and between students, out in front of everybody else, and multiple opinions held very passionately. There was no talk about money or careers. You would kick and yell and scream bloody murder . . . it wasn't an emasculating place.[13]

The loudest voice, the biggest fist—it is a little odd when art schools model themselves after Greenwich Village's Cedar Bar during the 1950s, where artists would line up to go ten rounds with Jackson Pollock.

If one doesn't adopt the Cedar Bar approach, there are some practical implications for effectively working within pluralism, including the acquisition of a language capable of discussing it. The study of form usually begins with learning the vocabulary associated with it. For instance, the formal properties of color are initially understood through the acquisition of terms such as *primary, secondary, complementary,* and *analogous.* And this language allows for a more conscious development of formal skills. In the same way, the evolution of a pluralistic approach to art depends on a vocabulary and a growing sophistication in using it. A way of talking about artists' social roles, diverse forms of audiences, and belief systems is as important to the creation of art as a knowledge of technique is. For example, knowledge of Sigmund Freud's theory of the fetish, the idea of the artist as social critic, and an audience's awareness of Hollywood cultural icons is particularly useful in understanding Andy Warhol's silk screen portraits of Marilyn Monroe. In the art school setting, this is the kind of integrated knowledge through which artists identify their own assumptions and critical perspectives, and put them to good uses.

Because art can function in society in widely differing ways, it is useful to examine those functions: art as object, as social action, as ideological expression. For the same reason, it is useful to examine the nature of art-making: Is art self-expression? Communication? In addition, the various roles of the artist in society enter into discussions of content: the artist as skilled worker, intellectual, entrepreneur, or social critic. The rationale for many of these questions and topics is not obvious, given the formalist history of talk about art—for example, a beginning painting class spends weeks on the application of paint, color theory, and stretching canvas, but rarely more than a passing moment on the difference between the artist as an entrepreneur and as social critic. But art is more than just formal structures; it is how those structures are put to use. And these structures are arrived at not through an unconscious hit or miss, but consciously and judiciously, in ways that allow for articulate discussion.

Such an awareness of art's multiple social functions makes dialogue possible, an open dialogue that allows one to examine overall objectives in the light of various critical perspectives. The important thing is that the dialogue is open, and not a series of clashing hidden agendas.

This dialogue assumes a pluralistic intellectual environment that allows for *consequential* discussion. Thus, a useful strategy is to find a way to deal with diversity in a manner that prevents diversity from losing its energy and its ability to change culture. One can encourage diversity, stifle it, or simply let it exist. Hal Foster despises the kind of pluralism that encourages diversity to the end of undermining the formulation of alternative ideologies. Foster's negative view of pluralism defines its diversity as a *goal*. But in exposing pluralism's dangerous blanket encouragement of diversity, Foster's argument against pluralism can prepare the way for an intrusive authoritarianism.

Given the inevitability of pluralism, how *does* one grapple with *Jacob and the Angel*? In discussing that painting, a number of important issues should have been given priority over the smaller issues and prejudices voiced by Instructors A, B, C, and D. First of all, there is the matter of the artist's intent, which obviously is to tell a story. Before any prescriptions were made, questions should have focused on the nature and meaning of this biblical narrative. Why, for instance, does the wrestling take place in a squalid urban parking lot specifically located in Champaign, Illinois, rather than in the "Promised Land"? What is the allegorical intent in choosing this narrative? What is the full context of the narrative? What is the tradition of this narrative in Western art? Does this painting support or subvert this tradition?

Second, the general purpose and social function of this work need to be part of the evaluative criteria. This artist, when pressed, acknowledges a desire to make liturgical and devotional art for a particular religious community. At the same time, he hopes the work is generally compelling to those less attuned to its message. The work has a highly specific and unusual social function. It was not made with the gallery's expansive white walls in mind. How will the primary audience, the religious community, see and use this work? The secondary audience, those outside of this community? These are questions that begin honestly to direct the artist's thinking and the meaning of the work without immediately imposing someone else's values and purposes. Such questioning helps the maker of the work to set the agenda, for unlike in Foster's or Bloom's versions of pluralism, there *is* an agenda. These are "responsible" questions, questions that can be responded to; they are not just a banal celebration of the oddball.

Art is a social act; artists manipulate images to refer outward, to the physical world, with all its visual, political, and psychological complexities. As the controversy surrounding *Tilted Arc* shows, different expectations for art can create conflict. Art is diverse, and attempts to make it into a single entity are doomed to fail, as in the cases of *Jacob and the Angel* and of formalism. The art world is, then, inevitably pluralist. This book is an attempt to describe and deal with that pluralism. It does so by presenting the social actions in which art is involved, and the following chapters provide a context for discussing those actions.

NOTES

1. Howard Finster (as told to Tom Patterson), *Howard Finster, Stranger from Another World: Man of Visions Now on This Earth* (New York: Abbeville Press, 1989), 123, 135.
2. Carlo McCormick, *Artforum* 28 (May 1990), 185.
3. "*Tilted Arc:* Hearing," *Artforum* 23 (Summer 1985), 99.
4. *Richard Serra: Interviews Etc. 1970–1980* (New York: Hudson River Museum, 1980), 186, quoted in Robert Storr: "'Tilted Arc': Enemy of the People?" *Art in America* 73 (September 1985), 90–97.
5. Kenyon Cox, "The 'Modern' Spirit in Art: Some Reflection Inspired by the Recent International Exhibition," *Harper's Weekly,* March 15, 1913, reprinted in *1913 Armory Show 50th Anniversary Exhibition 1963* (New York: Henry Street Settlement, 1963), 167.
6. Richard Hennessy, "What's All This About Photography?" *Artforum* 17 (May 1979), 24.
7. Ben Shahn, *The Shape of Content* (Cambridge: Harvard University Press, 1957), 123.
8. Joe Raffaele and Elizabeth Baker, "The Way-Out West: Interviews with 4 San Francisco Artists," *Art News* 66 (Summer 1967), 40, 75.
9. Lee Seldes, *The Legacy of Mark Rothko* (New York: Holt, Rinehart and Winston, 1978), 42–45.
10. Barbara Rose, "American Painting: The Eighties," in *Theories of Contemporary Art,* ed. Richard Hertz (Englewood Cliffs, N.J.: Prentice-Hall, 1985), 66.
11. Hal Foster, "Against Pluralism," in *Recodings: Art, Spectacle, Cultural Politics* (Port Townsend, Wash.: Bay Press, 1985), 31.
12. Thalia Gouma-Peterson and Patricia Mathews, "The Feminist Critique of Art History," *Art Bulletin* 69 (September 1987), 346–47.
13. Quoted in Kay Larson, "How Should Artists Be Educated?" *Art News* 82 (November 1983), 87.

Art and Belief Systems

Competing Theories and
Silent Complicity

When one paints one should think of nothing:
everything then comes better.
—Raphael to Leonardo

In 1961, the year President John Kennedy took office and the building of the Berlin Wall nearly nudged the world to nuclear war, Robert Morris disassembled his *Passageway,* a large plywood structure which had formed an entrance hall to his loft in New York. He cut it up with a Skilsaw, and used some of it to create a large triangle, to which he applied a uniform gray paint. Morris showed this untitled work at the Green Gallery in New York, where it sat at an angle in a corner to form a pyramid, surrounding and surrounded by empty space.

This triangle was seen as one of the classic pieces of minimalism, and Morris was that movement's prophet, working the premises behind this early sculpture into a coherent, uncompromising system. In the mid- to late 1960s he wrote a series of influential articles in *Artforum* in which he outlined some of the beliefs that gave rise to his early works. For Morris, minimalism had become the dominant art form; he proved it by claiming in 1969 that "one form, one material (at the most two) has been pretty much the rule for three-dimensional art for the last two years." Arguing for the primacy of "autonomous form," Morris championed simple objects, what he called "the simpler regular polyhedrons." These objects free the artwork as much as is possible from the complicating interrelationships that result from more elaborate visual representations and from variations in texture, color, and shape. Morris asserted that his simple objects have value because they "are relatively

more easy to visualize and sense as wholes." Near the end of one essay, Morris stated that "the sensuous object, resplendent with compressed internal relations, has had to be rejected."[1]

Twenty years after he disassembled *Passageway,* Robert Morris was again articulating his beliefs, beliefs that had changed from his earlier hermeticism in order to respond adequately to a world that he saw as changed. So in 1981, the year Ronald Reagan took office and initiated a national discussion of the Star Wars defense mechanism and of winnable nuclear wars, Morris wrote another ambitious article, in which he argued that a shift away from modernist minimalism had occurred because of "the more global threats to the existence of life itself." Morris prophesied the end of the world as coming from a variety of directions: "Whether this takes the form of instant nuclear detonation or a more leisurely extinction from a combination of exhaustion of resources and the pervasive, industrially based trashing of the planet, that sense of doom has gathered on the horizon of our perceptions and grows larger every day." Morris's tone as he nears the end of this rhetorically elegant essay grows apocalyptic: "In any case the future no longer exists and a numbness in the face of a gigantic failure of imagination has set in." He searches for a valid aesthetic sensibility to respond to this sense of doom, and finds it not in simple regular polyhedrons, but in what he calls "the decorative": "The decorative is the apt mode for such a sensibility, being a response on the edge of numbness. The decorative can be seen as the ultimate response to a pervasive death anxiety."[2]

Some time after he wrote this essay, Robert Morris repeatedly embedded his fist in wet plaster, and did the same with skulls, human noses, internal organs, and rope. He then cast this conglomeration with Hydrocal plaster, painted it, and used it as a decorative bas-relief frame. At the center of this piece, Morris worked with pastels to depict a nuclear firestorm, a Turneresque vision of yellows, ochres, reds, blues, black, and purple. He attached to it the following inscription: "None will be ready when it touches down. Yet we have seen it gathering all these years. You said there was nothing that could be done."[3]

With the possible exceptions of *censorship* and *unemployment,* probably no word produces more anxiety among artists than *theory.* Some artists revel in theorizing: contemporary artists such as Joseph Beuys, Adrian Piper, Frank Stella, and Peter Halley, and past figures such as Joshua Reynolds. More typically, artists dismiss theories of art as irrelevant or dull: among these artists are Robert Rauschenberg, Christo, Agnes Martin, and Louise Bourgeois. Still others in this larger group avoid, oppose, or are even hostile toward the idea of theories of art. Wassily Kandinsky maintained such an attitude. When early in the twentieth century he and Franz Marc were "branded as theorizing artists," he wrote defensively: "Nothing was far-

ther from my mind than an appeal to the intellect, to the brain."[4] (Kandinsky's defensiveness is particularly interesting given that he wrote the theoretical work *Concerning the Spiritual in Art*.)

Taken out of context, a phrase like "an appeal to the intellect" seems like a positive thing. Why, then, are so many artists put off by theory? One reason is found in the general cultural attitude toward art that questions its cognitive credentials, and deems it less an intellectual enterprise than, say, legal history is. The institutions of Western culture—from the church to the university to the judicial system—value words and language. By and large, visual art emphasizes a different "language" and kind of intelligence. This is not to say that visual art is nonintellectual. The education theorist Howard Gardner in his *Frames of Mind: The Theory of Multiple Intelligences* (1983) refers to the intellectual activity of visual art as *spatial intelligence,* an intelligence as central to chess as to painting. But a contrast still holds: Theory is a discursive practice; visual art is not. The translation from one language to the other is uneasy.

The split between theory and practice—that thinking about something and making something belong to two completely separate compartments of human activity—is merely a dramatic extension of this privileging of the verbal. It is a split that artists, more typically seen as involved in practice than in theory, frequently encounter. One reason conceptual artists such as Jenny Holzer receive such a nervous reaction from the general public is that these artists and their works seem to be questioning the boundaries between theory and practice. To the average viewer, Holzer's Times Square billboard (see Figure 1.4) seems to be theory rather than art.

In addition, the intellectual traditions of academia also support a theory–practice dichotomy. Theoretical physics has historically had more status on campuses than engineering has. Al Landa, then vice president of the New School for Social Research, commented in 1983: "There is a tendency to honor Ph.D.s, and the studio artist is, in the hierarchy of education, lower on the totem pole than any Ph.D."[5] Even within studio art, the more theorized disciplines such as painting and sculpture enjoy a higher status than less theorized disciplines such as textiles and ceramics. These traditions suggest that ideas are more important than and separate from their mere application. Individual artists may feel that they are both theoreticians and practitioners at the same time, with no distinction and certainly no sense of hierarchy. In the world in general, however, visual artists are only grudgingly granted the status of intellectual, never as readily as, say, novelists are. Artists are sometimes verbally inarticulate, and they get their hands dirty.

In such a hierarchical environment, some artists attempt to dismantle the hierarchy by denying the importance of intellect. This strategy arises from two different motivations. Some slip into an anti-intellectual position as they respond to prejudices that associate primarily words and language with the intellect. And so it is common to encounter artists who defensively refuse to talk about their work, who out of exasperation claim that their work has nothing to do with words, and that it speaks for itself. Some artists, however, reject intellectualism for more positive

reasons: rather than responding negatively to a feeling of exclusion from the intelligentsia, they actively adopt an anti-intellectual position, claiming that this position is responsible for the most powerful effects of their art. Max Beckmann was one such artist. In his essay "On My Painting" he wrote about his own brief attempt at theorizing: "These, however, are all theories, and words are too insignificant to define the problems of art."[6] (Beckmann then proceeded to discuss his work in a way that he believed more congenial to art, in terms of a personal experience: the intuitive and irrational meanderings of a very intense, detailed dream.)

Such a positive stance is seen in the painter Agnes Martin's art and writing. The critic Holland Cotter describes Martin's "emphatic and unapologetic" anti-intellectualism as a "privileging of intuition (or inspiration, as she prefers to call it) over intellectual thought, reflecting Zen's belief in the escape from knowledge that leads back to innocence."[7] In a lecture titled "Beauty Is the Mystery of Life," Martin asserts:

> All human knowledge is useless in art work. . . . There is so much written about art that is mistaken for an intellectual pursuit.
>
> It is quite commonly thought that the intellect is responsible for everything that is made and done. It is commonly thought that everything that is can be put into words. But there is a wide range of emotional response that we make that cannot be put into words. We are so used to making these emotional responses that we are not consciously aware of them till they are represented in art work.
>
> Our emotional life is really dominant over our intellectual life but we do not realize it.[8]

She may be anti-intellectual but, somewhat ironically, in her writing Agnes Martin also articulates a very complete theory of art, one that sees art in its simplicity as a form of spiritual and emotional exploration (finding its roots in Taoism), as tacit social commentary, and as a rejection of utopianism.

Another reason some artists reject theory is that theories, in their competition among themselves, seem to cancel one another out. One theory of art may focus on the art object and reject as unimportant anything "outside" the object, such as its maker, the purpose of the object, or the story it tells. For example, a formalist theory of art can address the decorative patterning of Marsden Hartley's painting *The Warriors* (1913), but it does not easily address the autobiographical homoerotic impulses that shape the work's subject matter and treatment. Another theory of art seems concerned only with the context of the artwork, that is, everything "outside" it; these theorists are interested primarily in the object's social purpose and may, in fact, be suspicious of objects themselves. For example, a Marxist theory might address the militarism of Hartley's painting, and argue that in its use of chivalric imagery the work ignores the class dimension of warfare in the twentieth century. The confusion of such theoretical frictions is often frustrating to artists who rarely have the time or inclination to smooth them all out.

Finally, as the preceding paragraph might suggest, such contradictions among theories are hardly friendly; in their rivalry, most theories have a tendency to expand their claims, to be all-encompassing. Artists often get cynical about theories because theories tend toward the hegemonic; their proponents see everything through the lens of their theory. That nearsightedness results in certain forms and aspects of art being overlooked. Psychoanalytic approaches to art, for example, while certainly useful in discussing some kinds of art are less appropriate to others—obviously relevant to Arshile Gorky's surrealist automatism, for example, but it seems less so to Josef Albers's squares within squares. As a theory expands, it either gets weak around the edges or excludes as art those things that do not fit its system or definitions.

That tendency toward the hegemonic further suggests that theories confer power, and they grant the power to exclude and to control art because they construct the definitions. Some kinds of art, the kinds that fit snugly with the prevailing theory, dominate art discourse. They are the artworks that critics call "mainstream." Such a mainstream discourse existed in the 1950s, when criticism focused completely on abstract expressionism, and the work of figurative artists like George Tooker was considered irrelevant. Besides, since artists are not usually the ones constructing theories of art, some of the power in the art world shifts away from artists to theorists. And the power of theory is used against artists as much as for them.

So there are some good reasons for artists to be wary of art theory. Usually, however, artists' overall attitude to theory is more psychologically based and intuitive than what we have just schematized: they have frustrations about theory, irritations with theory. Sometimes these reactions are the result of artists' feeling victimized by theory. Since many negative views of theory are so psychological, widespread, and variously motivated, they are difficult to counter with argument. But every artist (and probably every viewer of art) is engaged in theories of art, simply because they have some system of beliefs concerning art.

FUNCTIONS OF BELIEF

This is not to say that every artist is a theorist on the order of Hal Foster or Clement Greenberg, the most influential formalist art critic of the twentieth century. Most of the everyday, ad hoc theorizing about art seems far removed from the conceptual detail of overt, comprehensive theories such as Fredric Jameson's Marxist *The Political Unconscious,* or the feminist *Old Mistresses: Women, Art, and Ideology,* by Rozsika Parker and Griselda Pollock. Much of the discussion about art and about what artists do is more casual. It seems to go in either one direction, that artists and their works *reflect* the world, or another, that artists and their works *shape* the world. Viewers tend to see Fairfield Porter's bucolic depictions of middle-class family life, for example, as reflecting the world, while they see Jack Levine's

scathing images of corrupt social institutions as attempting to shape the world. Both of these attitudes about art, however, are about *social* actions: on the one hand, artists are mirroring a social situation; on the other, they are trying to change it.

The idea of art reflecting the world has its roots in Greek philosophical notions of mimesis; Plato's *Republic,* for example, claims that art is imitation. Few artists hold this extreme view of art as purely a mirror of reality, but language about art and arguments about it often assume a version of this passive view. Language about art is filled with references to art as responding to the world, revealing the world, reflecting a "spirit of the times," showing the way things really are. Art is thought of as a means of representing, recording, documenting, and thereby visually, conceptually, or emotionally revealing the world "as it is." In this view, artists are hypersensitive and highly skilled observers, reporters on life in the world. James VanDerZee's photographs of African-American life in Harlem during the 1920s and '30s fills this role. The domestic details captured in these photos function as a record of a way of life (Figure 2.1). This view of art and what artists do not only pertains to naturalistic, representational art but can be applied to the most abstract and conceptual artworks, since they also reflect emotional and intellectual life. Picasso said, "I paint only what I see. I've seen it, I've felt it, maybe differently from other epochs in my life, but I've never painted anything but what I've seen and felt."[9]

But the Greek philosophers also understood art as shaping the world in addition to reflecting it. Aristotle, expanding on Plato's views, recognized that art, even as imitation, had important, worthwhile effects on an audience: it brought forth emotion. However, because he also understood art as *knowledge,* Aristotle went much further in his claims for art than Plato did: "the delight in seeing pictures is that one is at the same time learning—gathering the meaning of things."[10] For this Greek philosopher, art was no secondhand reflection, but an active shaper of thoughts and emotions.

Today, many artists think of art as an even more aggressive force: as a way to change the world. Such an assertion means that art can visually, conceptually, or emotionally have a direct impact on the world; art can transform it, improve it. If the one view sees artists as reporters, this view sees artists as editorialists, opinionated promoters of ideas and causes. And this approach to art is not the sole province of muscular revolutionaries like Diego Rivera. Even the more lyrical, less overtly political Paul Klee wrote, "I do not wish to represent the man as he is, but only as he might be."[11]

"Reflecting" the world means something more than naturalistically representing the visible world, and "shaping" the world means more than physically altering the visible world. The word *world* here does not refer merely to the physical, visible environment; it is broadly applied to all the things the artist knows, perceives, thinks, and feels about external reality and accepts as true about it. An artist can believe that the New York art scene is corrupt, that painting is dead, that digital photography will replace other forms of image-making, that global economic

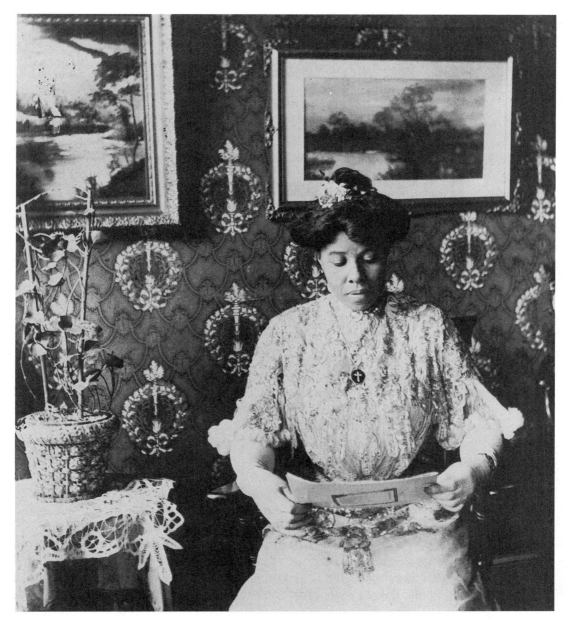

Figure 2.1 James VanDerZee, *Susan Porter,* c. 1915. Photograph. (© Donna VanDerZee. All rights reserved. Photo by James VanDerZee.)

collapse is imminent, that rainy weather makes people sad. All the things an artist accepts as true, from the most mundane to the most extraordinary, together form a belief system (sometimes called a worldview). Reference to the "world" is a general way of talking about belief systems, systems that are central to what people think and feel, and how they act, and it is belief systems that art shapes or reflects or both. And through art, the artist's worldview interacts with the worldviews of others.

For example, Frank Lloyd Wright's buildings have certainly shaped the way our physical world looks, but of course any building by any architect would do that. What is meant when people discuss Wright's impact on the world is that his work shaped beliefs about who people are and how they are to live. From a tradition that had always emphasized a building's autonomy, its dominance over nature, Wright designed structures that were organically related to their site and in harmony with their environment. Early in his career Wright set out the following principles about this relationship: "A building should appear to grow easily from its site and be shaped to harmonize with its surroundings if Nature is manifest there, and if not try to make it as quiet, substantial and organic as She would have been were the opportunity Hers."[12] In their relationship with their physical environment, Wright's buildings shaped systems of belief about people's relationships to one another and to nature.

The way Wright's buildings interact with belief systems is complex, and points to the fact that artists and artworks are always engaged in some degree of *both* reflecting and shaping. For instance, an assessment of Wright's work that omitted the fact that it reflected the West's early-twentieth-century interest in Japanese life and art would be an incomplete one. The dichotomy of reflecting–shaping comes from emphasizing one or the other side of a tension necessary in art production. Artists are addressed by their culture and they address it. Artists listen and artists speak.

Thus no artist is solely a shaper of the world. Even the most avant-garde, politically charged artist does not set in motion totally new thoughts, but also reflects the current situation. No contribution of new beliefs is totally new. For example, Jackson Pollock's drip paintings apparently set the art scene on its ear in their attempt to redirect people away from thinking about painting as an object and toward thinking about painting as an action. But it was a *redirection,* not a creation out of nothing. Pollock's work had power to accomplish this change because it had precedents that made it communicable, precedents that are belief systems: formal elements like the cubist fracture of the surface; beliefs about the human mind, such as surrealism; and beliefs about the spiritual, especially romantic ideals of the transcendental. The notion of the artist shaping the world through the creation of totally new belief systems is naive.

Even an artwork that is firmly within an established tradition (and therefore not attempting to *change* the world) will contribute to that tradition's support and thus, albeit negatively, shape the world, favoring one belief system over another.

John Singer Sargent, for example, helped shape the world in terms congenial to the status quo of his socialite subjects.

Likewise, but perhaps less obviously, the notion of the artist as an objective, dispassionate observer of the world is untenable. As soon as even the most realist artist selects a subject, she has engaged in an interpretive act. She has stated that something is worthy of attention, as Dorothea Lange did in her Depression-era photographs of migrant farmworkers.

Despite the fact that artists cannot be completely objective and dispassionate, some contemporaty artists claim to be neutral observers, though in a very specific context. The neutral-observer defense is offered when an artist's work deals with sensitive subject matter, such as when a film violates the conventions regarding acceptable violence, or when photographs depict taboo forms of human behavior. The artist, so the argument goes, "is just showing us the way things are." For example, Nan Goldin argues that her collection of photographs *The Ballad of Sexual Dependency* is a neutral report: "I don't judge what I'm looking at. I don't name or analyze it. I just accept what I'm looking at as being what it is. . . . I see people as who they are."[13] In his *Close to the Knives: A Memoir of Disintegration,* the gay artist David Wojnarowicz makes essentially the same claim in arguing against the attempt by Senator Jesse Helms and others to censor art that deals with sexuality: "Boneheads such as Phyllis Schlafly and Pat Buchanan have represented [Senator Jesse] Helms in the media, whining that public funds should not be used for art or educational material that reflect the true diversity of sexuality in this country."[14] But again, selecting what to show (making art to "*reflect* the *true* diversity of sexuality in this country") is already an interpretive act, with a critical agenda. And, as his highly charged writings assert, Wojnarowicz himself would certainly agree that his selection of images for his *Four Elements* series has a political intent: it comes out of his beliefs about the value of his own sexuality, and the homophobic nature of American society (Figure 2.2).

Engagement with the world in this tension of responding to and projecting beliefs, of reflecting and shaping, is an engagement with systems of belief about the world. Because this sort of responding and projecting describes the dialogue character of art, this tension is a central feature of any discussion about art. Art is not philosophy, and artworks are not necessarily (some would say should never be) illustrations of ideas. But art, like *everything* one does, is an expression of belief systems.

THE NATURE OF BELIEF SYSTEMS

These beliefs, in turn, are a mixed lot. The contours of a belief system are directly and indirectly influenced by such cultural factors as education, religion, family, gender, race, ethnicity, tradition, and social class. Whatever artists choose to do with

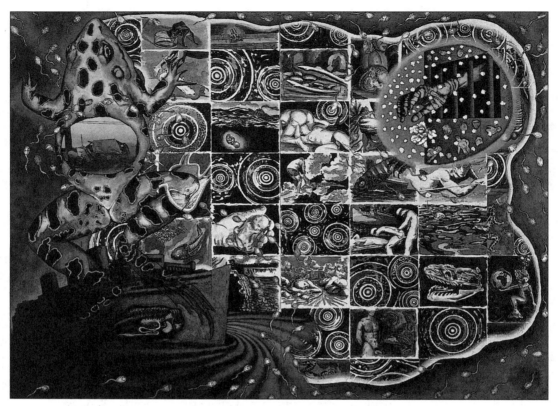

Figure 2.2 David Wojnarowicz, *Water,* 1987, part of the *Four Elements* series. Acrylic and collage on wood, 72" × 96". (Courtesy of the Estate of David Wojnarowicz and P.P.O.W., NY.)

their art, whatever social role they take on, their work is laden with beliefs about art, and about human, cultural, and environmental relationships. An artist's deepest commitments, which are often labeled with religious or ideological affiliations, bear on an artist's works (as do many of her less strongly held and temporary commitments). And the works reciprocate: they imply these beliefs, reflect these presuppositions. John Cage's prints and drawings, with their random, nonhierarchical organization, were an integral part of his Zen Buddhist approach to life—and vice versa. It is not, however, always the obvious and specific relationships between such beliefs and art that have the widest impact—relationships such as the orthodox Muslim's rejection of human representation or the orthodox Marxist's demand that art participate in class struggle. Rather, it is the subtle and often more general relationships, things like the Muslim ideal of beauty (and view of death) that created the Taj Mahal, or the socialist utopianism that created Russian constructivism.

Artworks, then, imply a whole system of beliefs about the world. Briefly put, a *belief* is what a person holds as true about the world; a *belief system* is an interrelated set of beliefs. People use these interrelated beliefs to organize their perceptions and give them meaning.

When beliefs are organized by some consistent principle and are used to present a systematic approach to art, they constitute a *theory* of art. Theories are more narrowly focused, conscious parts of belief systems. They work to provide explanations for and have clear applications to their subject. For example, a Marxist theory of art organizes beliefs about art by its overarching economic principles. Likewise, a psychoanalytic theory of art organizes its tenets about art by its larger Freudian psychological tenets. A similar pattern can be found in formalist, structuralist, post-structuralist, and feminist theories of art. They get their power from being coherent, all-explaining, logically neat. Their all-embracing character is central to their function, for when a theory has an inconsistency or cannot account for a central aspect of human behavior, it loses much of its power.

Sometimes artists are very conscious of the expression of beliefs in their work. Artists as diverse as Donald Judd and Judy Chicago have developed their art within clearly understood and well articulated, explicit systems of belief. Judd was called the philosopher of minimalism, and Chicago promotes feminist collaboration. It is clear from their art and writings just where they want to position their work in relationship to important issues of the art world and society. They forcefully and explicitly state their convictions.

But often, perhaps most frequently (some would say at best), art is an *unconscious* expression of belief—various beliefs are implicit in the art. The deeply personal, somewhat surreal sculptures of Louise Bourgeois or the expressionist portraits of Alice Neel also interact with art and society, but with more ambiguity and less obvious theory. Neel and Bourgeois do not publish polemical or theoretical articles in *Artforum*. All the same, works such as Bourgeois's bronze *Nature Study* (1984) or Neel's nude *Self-Portrait* (1980) were developed within a set of convictions about art and society. For example, both artists value—believe in—modernist notions of originality and self-expression.

All artists, even Donald Judd and Judy Chicago, are never fully aware of all the beliefs that come to expression or are implied in their work. While Neel's and Bourgeois's work develops within this modernist framework, it may do so in an unconscious, unsystematic way. This is neither a condemnation nor a celebration of the intuitive—such a lack of full awareness about one's art is no different from the incomplete awareness of any other human activity. Ted Turner, founder of CNN and owner of the Atlanta Braves, may have a rigorously thought out position on the relationship between news and professional sports; he may not be nearly as conscious of how his beliefs about gender impinge on that relationship. Turner's beliefs are unconscious, but they contribute to his actions. In that relationship between unconscious beliefs and actions, Turner's beliefs do not function much differently from what is often perceived as a classic reaction to art: an attempt to define what is (and especially what is *not*) art. Such unconscious beliefs are unexplained, yet they result in clear action; they allowed Teddy Roosevelt to stride energetically through the 1913 Armory Show of avant-garde American and European art, stating a clear belief based on very unclear principles. Apparently, Roosevelt, furious about the art he was seeing, "waved his arms and stomped through the Galleries pointing at pictures and saying 'That's not art!' 'That's not art!'"[15]

The presuppositions implied by an artwork can sometimes be so universally held within a specific community that no one seems to notice them. The artwork is thought to be neutral regarding belief; it expresses no beliefs. But in fact, such a work inevitably serves some belief system, quietly maintaining the set of widely shared convictions, commonly held assumptions. This is what is meant by the often-heard phrase "All art is political." No artworks are neutral about or devoid of beliefs (and beliefs have political implications).

According to some historians, abstract expressionism presents a striking instance of such unconscious assumptions. The critic Serge Guilbaut has argued that abstract expressionism "saw itself as stubbornly apolitical [but] came to be used as a powerful political instrument."[16] In an earlier version of this thesis, the critic Eva Cockcroft claimed that neutral-seeming abstract expressionism actually served the belief systems and interests of cold-warriors, CIA directors, and American corporate interests. But this is not another story of the artist as victim, for the beliefs and work of politically naive artists were not merely co-opted by the beliefs and interests of the wealthy and powerful; Cockcroft argued that co-option is too passive a word to describe the interrelationship between the two. She asserted that "Abstract Expressionism constituted the ideal style for these propaganda activities." Further, abstract expressionist artists, not just their style, were complicit in the use of abstract expressionism by cold war interests, for "avant-garde artists generally refused to recognize or accept their role as producers of a cultural commodity," and therefore "abdicated responsibility . . . [for] the uses to which their artwork was put after it entered the marketplace."[17]

Despite their emphasis on formal values, then, the artworks of Pollock, de Kooning, Kline, Still, and others were not neutral regarding political beliefs. What

results is a tangle of "pure" aesthetics and politics:

> By giving their painting an individualist emphasis and eliminating recognizable subject matter, the Abstract Expressionists succeeded in creating an important new art movement. They also contributed, whether they knew it or not, to a purely political phenomenon—the supposed divorce between art and politics which so perfectly served America's needs in the cold war.
>
> Attempts to claim that styles of art are politically neutral when there is no overt political subject matter are as simplistic as . . . attacks on all abstract art as "subversive."[18]

Through exhibitions sponsored covertly by the CIA and promoted internationally by the Museum of Modern Art—whose board was completely enmeshed in American government interests during this McCarthy era[19]—the "triumph of American painting" and the success of a large group of painters were assured. Both the painters and the government benefited in this arrangement. Although the artists themselves surely had little or no knowledge of the specifics of this co-option of their work to support the beliefs of others, neither can they successfully deny the general cultural assumptions implied by their work—in this case, individualism and self-expression as the highest forms of freedom, and an acceptance of artworks as commodities.

The conscious or unconscious reasons for a person's beliefs are not all arrived at the same way. A lot of the things a person may accept as true are easily proved, such as a belief that blue and yellow make green, and sometimes not easily proved, such as a belief that two people who look at the same color actually perceive the same color (maybe they both just call very different sensations by the same name). Some beliefs come from carefully reasoned arguments and evidence, and others come from an intuitive, immediate acceptance of an idea. For example, the Rembrandt Research Project, a committee of experts sponsored by the Netherlands Organization for the Advancement of Pure Research, has in recent years "demoted" many Rembrandt paintings to the work of his students. These controversial judgments are backed by elaborate technology and reasoning: dendrochronology, X-rays, neutron activation radiography, infrared photographs combined with historical documentation and comparison with known work of his students. But this elaborate reasoning does not always carry the day. In a display of intuitive connoisseurship, the scholar John Gash asserts that the Berlin *Bust of Rembrandt* reattributed to Govaert Flinck should remain a Rembrandt *Self-Portrait*. While Gash cites brushwork and color, he submits as his final piece of evidence the *Bust of Rembrandt*'s "soft slightly vulnerable dreamy quality that is not uncharacteristic of Rembrandt's self-scrutiny"—in others words, it just *looks* like a Rembrandt.[20]

Whether conscious or unconscious, covert or overt, one's beliefs are interactive and interconnected, and in their interrelationship they form a heterogeneous, lumpy whole. Both the interrelationship and the lumpiness are integral characteristics of belief systems.

Interrelatedness

First, beliefs are interrelated. Whether conscious or unconscious, Pollock's beliefs about cubist fracturing of surface are not independent from his beliefs about surrealistic forms of expression. Further, some beliefs are logically constructed out of other beliefs. The scale of Pollock's paintings is partially dependent on romantic transcendentalist beliefs.

Beliefs that are necessary to the construction of other beliefs and that we assume in order to hold a particular conviction are called *presuppositions*. Typically, presuppositions are unmentioned, *implicit* beliefs on which specific *explicit* beliefs, theories, and actions (such as decisions, judgments, evaluations) are based. *Presupposition* is a relational term indicating a belief that must be accepted prior to holding a second; it does not characterize the belief's content. Presuppositions are always in service *to* something else. When, for example, an archaeologist encounters a large marble head embedded in hardened mud near Naples, she believes it is part of a Roman statue, and therefore she assumes it was carved by a sculptor and not, say, coughed up in perfect classical proportion by Mount Vesuvius. In order to do this, she presupposes the object had a human maker, and that effects have causes. She does not stop to think through these necessary presuppositions; however, they are implied by her belief that the work is by a Roman sculptor.

But some presuppositions are more controversial and more interesting than this mundane example. When a critic boldly asserts that Picasso is a much more important artist than Matisse, a whole host of presuppositions must be suspected. In his contribution to a symposium on Matisse, the critic Robert Rosenblum confesses his youthful preference for Picasso over Matisse:

> In what was usually presented as an either/or situation, Picasso versus
> Matisse, I always opted for the pictorial theater whose dramas embraced
> comedy and tragedy, heaven, hell, and earth. Next to the demonic magic of
> an artist who could turn newspapers into people, open satanic vistas of sex
> and death, and make the old masters' ghosts breathe again with an eerie new
> life, why should one exert oneself over a narrow-minded French master who
> offered only a terrestrial paradise of comforting luxury products, the pictorial equivalent of haute cuisine and haute couture?[21]

At that time, Rosenblum believed Picasso to be heroic and Matisse to be merely decorative. He assumed that heroic inventiveness was all-important and that decorativeness was a defect. If others disagreed with Rosenblum, they needed to argue different conclusions from the same presuppositions, and/or examine and attack the presuppositions.

Many presuppositions implied in a belief can be very debatable. Since tribal masks resemble some modern Western sculpture, it is tempting to conclude that they belong in the museum in the same way Western art does, that they are art objects in

the same sense that the Western sculptures are. But of course this conclusion is based on the false assumption (false to all but the hard-core formalist) that when objects look alike, they have a similar meaning or can at least be talked about and evaluated in a similar way. (But then this example presupposes that art museums should be places of consistent systematization of work with a similar social purpose—perhaps *this* is a false assumption.) In Chapter 1, four instructors each presupposed very different purposes for Rick Beerhorst's *Jacob and the Angel*. Each saw the painting as implying something different, such as narration, or self-expression, or mystic introspection. Chapter 3 will demonstrate that various social roles of the artist are based on very different sets of presuppositions about artists' work. And Chapter 4 will show how differing presuppositions about art can create conflicts between artists and their audiences.

Heterogeneity

But this talk about presuppositions shows that belief systems are not just interrelated; they are also lumpy. That is, they contain all kinds of incoherences that would not be admitted into a rigorous *theory* of art such as formalism. Consider, for example, Jackson Pollock's drip paintings of the late 1940s. They developed out of a surrealist interest in automatism, but their "all-over" quality and acknowledgment of the flat surface of cubism freed Pollock from surrealism's reliance on objects and implied narratives. That tension—despite its failure to logically reconcile disparate and contradictory theories—is one of the things that people value in Pollock's work. The same could be said of Russian constructivism's interest in both formalism and social change: the two do not contradict each other, but they form an uneasy tension.

Artworks can also be self-contradictory in their relationship to broadly ideological or religious belief systems. They can claim a connection to a specific set of beliefs that is then denied by some other aspect of the work, or they can attempt to combine systems that are inherently contradictory. At best, these works may be attempts by artists to resolve or express tensions in their own worldview, and perhaps create a new synthesis. But they can also simply be muddled thinking. Salvadore Dali's "Christian" paintings are a good example. These works, the object of widespread Christian devotion, are a blend of pious religious imagery and surrealism, two approaches to art with antithetical presuppositions that systematically and aggressively oppose each other. They do not just tangentially deflect off each other. The socialist who makes high-priced objects that are available only to the wealthy is an even more common instance of clashing beliefs.

The lumpiness of belief systems partly comes about because belief systems or worldviews of artists are not closed sets of immutable principles. They are dynamic; they grow and adjust, influenced by changing knowledge and experience. In the 1950s, Philip Guston painted completely nonreferential abstractions—floating,

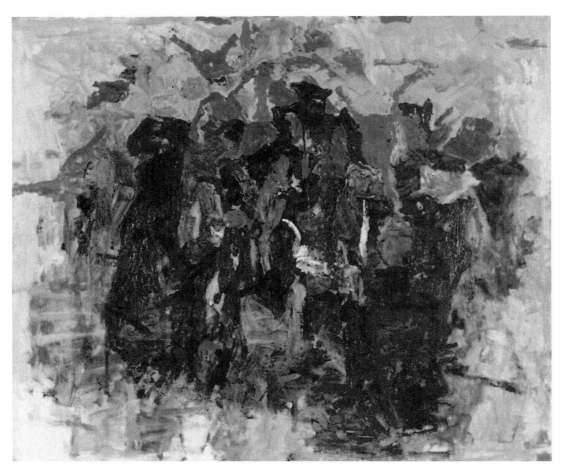

Figure 2.3 Philip Guston, *Fable,* 1956–1957. Oil on canvas, 65" × 75".
(Collection of the Washington University Gallery of Art, St. Louis, Missouri. Courtesy
McKee Gallery, New York.)

lyrical, irregular grids of thick brushmarks that in their atmospheric color were often compared to impressionism (Figure 2.3). According to the critic Robert Storr, Guston believed in a "fundamentally nonreferential aesthetic" that some critics at the time thought would take painting to an extreme of solipsism.[22] In 1970, Guston shocked the New York art community with an exhibition of paintings that depicted crude, cartoonish, hooded figures driving old cars in a landscape of urban decay and an atmosphere of impending violence (Figure 2.4). Guston's shift in beliefs about art's contact with the world took everyone by surprise. Hilton Kramer wrote a withering review in the *New York Times* titled "A Mandarin Pretending to Be a Stumblebum."[23] Alienated from friends who felt betrayed by his new commitments, and from his gallery, whose support was lukewarm, Guston was left without a community of support. The situation changed dramatically a few years later when Guston became the champion of a new generation of expressionist, image-based painting.

As their belief systems develop, people adopt a great variety of beliefs, and hold to them on many different levels of commitment and consciousness. Through these beliefs, they organize their perceptions and give them meaning. The purpose of examining belief systems here is not to examine whether beliefs are right or wrong, or logically consistent, but to see what artists *do* with their beliefs, and how beliefs function in the production of art.

BELIEF CONFLICTS

An artist's belief system is not purely individual. It finds its sources in beliefs external to the artist; it is shaped by interaction with others in various communities of shared belief. As mentioned earlier, belief systems are influenced by cultural institutions and are formed in communities that accept the members' various presuppositions, communities bounded by such things as gender, race, ethnicity, education, religion, and social class. And since everyone is grounded in a language and in codes generated out of a tradition, a totally individual, independent belief system is impossible. Furthermore, Western artists' beliefs about art share a common focus, even when they may take opposite approaches to it. Consider the apparent dissimilarities between Jenny Holzer's digital billboards and Lucian Freud's figurative paintings (see Figures 1.4 and 1.5). Despite their extreme differences, they both have a positive attitude toward individualism, they both pursue originality, and they are both skeptical about ideas of human progress. They both address Western obsessions such as Individualism, Originality, and Progress.

Further, a totally individual, independent belief system is hardly something anyone would want: communication depends on mutually understood assumptions. Even the most avant-garde art gets its power from addressing such assumptions. For example, in 1971 the performance artist Chris Burden arranged for a friend to take

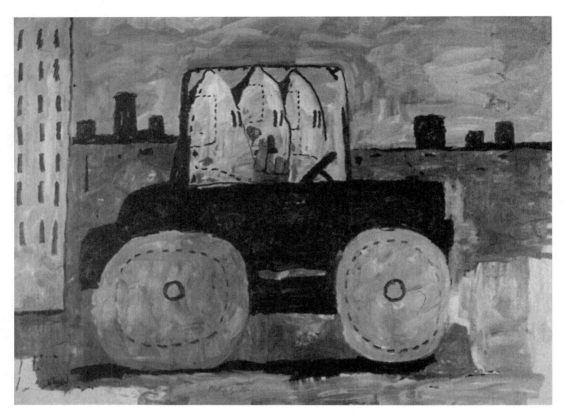

Figure 2.4 Philip Guston, *City Limits,* 1969. Oil on canvas, 72" × 103¼".
(Collection of the Museum of Modern Art, New York, gift of Musa Guston. Courtesy
McKee Gallery, New York.)

a .22-caliber rifle and shoot him in the arm. The bullet, intended to graze Burden, in fact seriously wounded him. To the general public, *Shooting Piece* was inscrutable as art, an act whose only role may have been as an amusing or scandalous anecdote at the end of the evening news. But to the art community—who if they did not share Burden's assumptions about art at least understood them—Burden's work raised serious questions about the representation of pain. Even those most antagonistic to Burden could recognize *Shooting Piece* as pushing the boundaries. And this recognition was possible only because the assumptions behind Burden's testing the limits of visual art were *communicable* assumptions.

Yet even though belief systems are communal in their formation and purpose, they can still be highly idiosyncratic. They are made up of too many elements for any two systems to be exactly alike. And especially in Western culture, where the concept of individuality carries power and prestige, a certain amount of tension between personal and communal beliefs is constantly present. Some of the idiosyncratic beliefs of the Reverend Howard Finster—for example, that he receives his personal revelations from God—are incomprehensible to many and lead to serious misunderstandings of his work. But the work still communicates a great deal, because both Finster and his audience accept certain conventions about paintings and art objects: how they are to be contemplated as expressions of emotion and ideas, and how they are to be seen as the work of an aggressively unique individual.

Because differing beliefs are an inherent characteristic of postmodern art culture, the art world is always in conflict as these views jostle for position. Yet the art world has also developed a laissez-faire, pluralistic attitude toward art. The classical realist figurative works of William Bailey are exhibited in the same gallery districts as the stacked video installations of Nam June Paik, both are seen by the same people, and both are reviewed in the same art magazines. Chapter 1 discussed some of the problems that result in the art world from this sort of pluralism: pluralism is attacked for its poverty of values and its slide into relativism (Bloom), and for its hindering of ideological commitment (Foster). On the other hand, pluralism is a fact, and the alternative to it seems to be authoritarianism. Furthermore, pluralism doesn't have to imply a sacrifice of principle—one can argue passionately for a belief and still respect the rights of others to hold contrary beliefs. The acceptance of pluralism, then, doesn't mean the end of conflict. But it does mean the conflict should be between the ideas and beliefs expressed, not about whether some beliefs should have access to the arenas of discourse—museums, galleries, magazines, and TV screens.

Earlier in this chapter we argued that art *shapes* the world, and shapes beliefs about the world. Of course, there are different types of shaping: a piece of art can be heroic and change views about a political cause, a disposition toward a social group, or a perspective toward an aesthetic principle. Picasso's *Guernica,* Ansel Adams's photographs of Yosemite, and Duchamp's urinal all shaped beliefs. But changing beliefs is not the most common way for artworks to interact with the beliefs of others. Change doesn't always happen. It is more common for people to

test these beliefs; they try them on. There is both generosity and distance implied in this phrase. On the one hand, trying something on can imply an open-mindedness, generosity, tolerance. On the other hand, it can also lead to passivity, ennui, mere fashion. But the typical fact about both aspects is that they presume the availability of a noncoerced choice on the part of the viewer.

But this process of trying on beliefs can cause uneasiness. "Trying on beliefs" suggests choice; however, beliefs in contemporary art often confront viewers in a more aggressive way, attempting to leave no choice to the viewers. For example, art-works with a strong political agenda can assault viewers with problems they would rather ignore. Sue Coe's Malcolm X pieces, with their bishop/sharks and decapitated, grotesque politicians, are insistent in their assault (Figure 2.5). Viewers have no opportunity to mull over alternatives. Other kinds of art, particularly those using sexual imagery, can involve the viewer in some of the consequences that result from holding a specific belief, and can do so without the viewer's assent—participation in the beliefs is sometimes automatic in the viewing of the image. Annie Sprinkle's performance art does not just border on pornography, and elicit responses common to pornographic work. In a high-art setting, it necessarily creates a complicating uneasiness, an irritation at being involved, a breaking down of a sense of the private, and a feeling of voyeurism.

And that is perhaps the more interesting and complicated arena in which belief conflicts occur in contemporary art: not that of public art, where attempts at coercive social change abound, but that of more personal, intimate art, where individuals are manipulated by or brought into complicity with the artist. In its most extreme form, such art makes the viewer an accomplice in violating some taboo, and the viewer experiences the accompanying thrill and/or guilt. The voyeurism of the photographs of Diane Arbus, Joel-Peter Witkin (Figure 2.6), and Robert Mapplethorpe are clear examples. Other art flirts with the conventions of pornography, shocks viewers with the depictions of extreme violence, or blasphemes a group's sacred beliefs. Such artworks do not merely present beliefs to be "tried on"; they immerse their viewers in the consequences of a belief, engage them in participation through the act of viewing. Viewers are made to feel a complicity in the violation, or to be violated themselves. For example, the critic Deborah Drier writes of Cindy Sherman's use of the witch figure of fairy tales that "Sherman pushes the metaphor [of witch/female ego] further, implicating the spectator in the risk and thereby rendering the danger more concrete. Looking into the blazing eyes of her malignant creatures, or regarding the pathetic fate of the fallen, one cannot doubt the possibility of being cursed oneself."[24] That complicity, that identification (perhaps unwilling), gives this work its power.

In May 1979 at the Artemisia Gallery, a women's cooperative gallery in Chicago, artist Joy Poe arranged to have herself raped at the opening of her exhibition, "Ring True Taboo." The rape occurred without warning or notice, but afterward cards were handed to the spectators which explained that the event was a performance. The critic Joanna Frueh wrote, "In brutalizing herself, her co-'performer,'

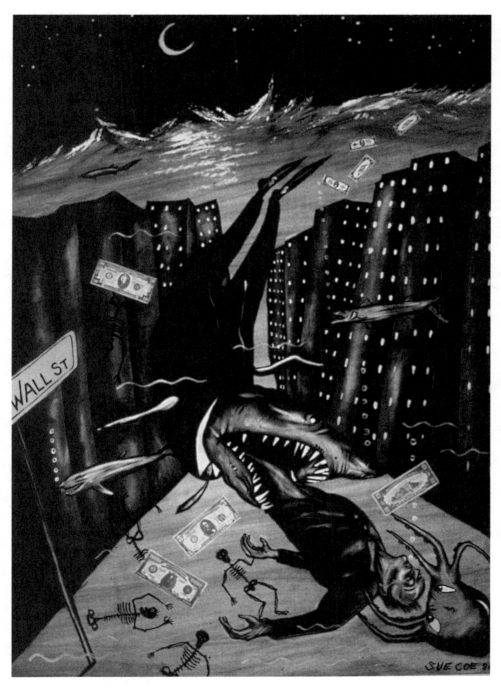

Figure 2.5 Sue Coe, *Wall Street*, 1985. Graphite, watercolor on paper, 30" × 22".
(Copyright © 1985 Sue Coe. Courtesy Galerie St. Etienne, New York.)

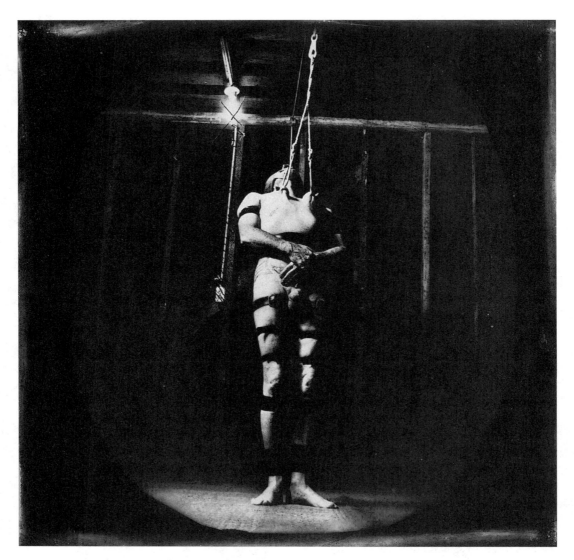

Figure 2.6 Joel-Peter Witkin, *Mandan,* 1981. Photograph. (Copyright Joel-Peter Witkin. Courtesy PaceWildensteinMacGill)

and her audience, Poe was both cruel and cunning." Frueh also referred to the performance as "manipulative."[25] Poe's social beliefs were imposed on an audience in such a way that the members of the audience, as witnesses, were forced participants. In fact, the rape was structured so that viewers could not intervene. Poe had planted confederates in the crowd to protect the "rapist" during the rape.[26]

Viewers responded angrily to their forced complicity, writing outraged letters to the *New Art Examiner.* Chicago artist Phyllis Bramson objected that Poe "willfully and brutally brought about a violent plundering of Artemisia Gallery, to the horror of those people trapped into witnessing Poe's 'raping' of Artemisia." Another correspondent wrote of her resentment at being forced into the "role of innocent bystander and the inference of compliance." But a few audience members *supported* the work for the same reasons. One stated, "People are outraged because they had no control over what happened in the performance and their involvement in it."[27]

Complicity doesn't always encourage such a negative response. The Holocaust Museum in Washington, D.C., with its powerful reproduction of a concentration camp and its horrific documentation of genocide, instills a sense of guilt in the visitor, guilt rooted in awareness of surviving when others have not. Similarly, Leon Golub's paintings of sadistic mercenaries and interrogators bring viewers into a situation where, fascinated with and then repulsed by the violence, they are forced to respond to what they are implicated in (Figure 2.7). Creating complicity can bring about positive action. So the issue is not just whether the work compels complicity in its viewers; a more complicated nexus of issues is involved. These works raise issues such as the sorts of beliefs and actions with which one becomes complicit, the intensity with which the work compels involvement, the intended ends or social purposes of the work.

But complicity, forced participation in a work's projected beliefs through the act of viewing, is not always as obvious as it is with the Holocaust Museum or with Joel-Peter Witkin's *Mandan.* Complicity is easy to see in the extreme cases, where a *conflict* of belief is anticipated, but it is more difficult to detect when the artwork supports beliefs the viewers were unaware that they had. Perhaps the work and the viewer share common presuppositions that go unexamined, creating a voluntary but unconscious acquiescence.

For example, in 1991 the Smithsonian Institution organized an exhibition at the National Museum of American Art titled "The West as America: Reinterpreting Images of the Frontier, 1820–1920." The works in this show were ones that had had a formative influence in American culture. According to one critic, "When we think of emblematic national events, what comes to mind are 19th-century American history paintings, works whose fame derives less from their status as serious art than from their endless reproduction in high school history books."[28] Another critic described the show as an attempt "to debunk traditional histories of the frontier which romanticized progress but rarely noted the disastrous effects of Western expansion on Native American tribal life or the environment."[29] The exhi-

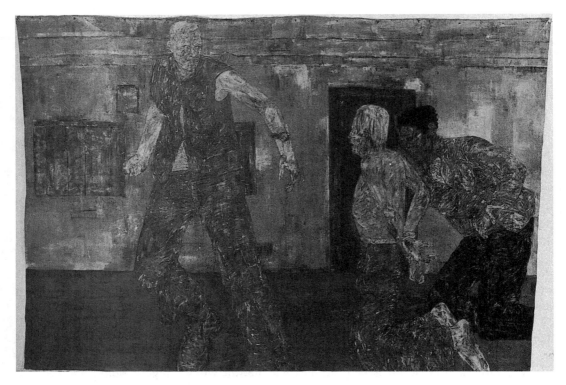

Figure 2.7 Leon Golub, *Prisoners I,* 1985. Acrylic on unstretched linen, 120" × 171". (Photo courtesy Ronald Feldman Fine Arts, Inc., New York.)

bition challenged commonly held myths of American westward expansion and revealed how they are embodied in the artworks of the time. In its installation, wall labels, and catalogue, the exhibition seemed to suggest that the uncritical acceptance of paintings by such artists as George Catlin, Charles M. Russell, and Albert Bierstadt implicated the viewer in racism, conquest, and expansionism. For many viewers, this was not an easy proposition to swallow; they reacted with angry denial: "True believers reacted with pain, disbelief and anger at seeing adventure and settlement recast as expansion and conquest: with the terms reversed and revalued, pride became an occasion for shame."[30] The controversy over the show ultimately involved members of Congress who threatened the budget of the Smithsonian. Others claimed that the exhibition was a revelation. Visitors expressed their conflicting reactions in the comment book:

> It is embarrassing, sad, and scary to hear the truth sometimes—especially when you must admit that you have wronged someone else. I have never considered the possibility of such propaganda on such a large scale.

> I will always imagine myself as a pioneer or a railroad man settling the West. These pictures are wonderful. The propaganda in them does not destroy my dream—the reality of the West is not available to us or to the curator of this exhibition. I didn't need to be told that Catlin's pictures were propaganda— phooey. I'm happy with the myth. I cried like a baby at *Dances with Wolves*—I loved it. I know the scholars and curators would have poopooed my red eyes.[31]

General cultural complicity does not just involve the beliefs revealed by the Smithsonian show. One could go on, listing early modern depictions of women or the colonialist attitudes implied in seventeenth-century still-life painting.

The art world is the scene of inelegant conflict. The conflict comes about not just because beliefs overtly clash with one another, but because they interact in much less obvious ways. When beliefs of artist and audience are askew, as in the case of Guston's work, they can become ways of limiting a relationship between an artist and his audience. Or, as in the case of the Reverend Howard Finster's religiously inspired folk art, idiosyncratic beliefs can become a way of enhancing a reputation even as they are seriously misunderstood. The conflict between Finster and his audience fuels much of his reputation, in which apparently the only thing that remains communicable is a belief in the individual artist as creating genius: Finster as the prophet of God, or Finster as the quirky Georgia preacher whose obsessions give rise to compelling images. Belief systems still manage to do their work, sometimes silently sliding by each other.

As artists and their artworks engage in social interaction with the larger world, their belief systems reflect and shape the world. Belief systems, in their sprawling organization, are both interrelated and heterogeneous, and within these lumpy

systems are neater, more coherent *theories* of art. Although many artists resist art theories, they all have them, and since the broader belief systems in which these theories reside differ widely from one another, conflict is chronic. These disagreements aren't just about specific subject matter and theories. They extend to arguments about the general function or role artists perform in society and to the artist's relationship to an audience—the topics of the next two chapters.

NOTES

1. Reprinted in *Continuous Project Altered Daily: The Writings of Robert Morris* (Cambridge: MIT Press, 1993), 3, 6, 7, 17, 54.
2. "American Quartet," *Art in America* 69 (December 1981), 104.
3. Edward F. Fry, *Robert Morris: Works of the Eighties* (Newport Beach, Calif.: Museum of Contemporaty Art; Newport Harbor Art Museum, 1986), 94.
4. Wassily Kandinsky, "Reminiscences," in *Modern Artists on Art,* ed. Robert L. Herbert (Englewood Cliffs, N.J.: Prentice-Hall, 1964), 42–43.
5. Quoted in Kay Larson, "How Should Artists Be Educated?" *Art News* 82 (November 1983), 87.
6. Max Beckman, "On My Painting," in *Modern Artists on Art,* 136.
7. Holland Cotter, "Agnes Martin: All the Way to Heaven," *Art in America* 81 (April 1993), 93.
8. "Selected Writings," in *Agnes Martin,* ed. Barbara Haskell (New York: Abrams, 1992), 10–11.
9. *Picasso on Art: A Selection of Views,* comp. Dore Ashton. (New York: Penguin, 1977), 66.
10. *Aristotle's Art of Poetry,* trans. I. Baywater, ed. W. H. Fyfe (Oxford: Oxford University Press, 1952), 9.
11. Paul Klee, "On Modern Art," in *Modern Artists on Art,* 90.
12. *Architectural Record,* March 1908. Reprinted in *In the Cause of Architecture: Frank Lloyd Wright,* ed. Frederick Guthei (New York: McGraw-Hill, 1975), 55.
13. Stephen Westfall, "The Ballad of Nan Goldin," interview in *Bomb* 37 (Fall 1991), 31. This is not to say that other arguments about the work's merits are then put aside. A few moments later in the interview, Westfall comments to Goldin that her work "has a definite activist edge to it." Goldin responds: "Definitely" (31).
14. David Wojnarowicz, *Close to the Knives: A Memoir of Disintegration* (New York: Vintage, 1991), 148–49.
15. *1913 Armory Show: 50th Anniversary Exhibition 1963* (New York: Henry Street Settlement, 1963), 94.
16. Serge Guilbaut, *How New York Stole the Idea of Modern Art: Abstract Expressionism, Freedom, and the Cold War,* trans. Arthur Goldhammer (Chicago: University of Chicago, 1983), 190.
17. Eva Cockcroft, "Abstract Expressionism: Weapon of the Cold War," *Artforum,* June 1974, 39, 40.
18. Ibid., 41.

19. For example, Thomas W. Braden, supervisor of CIA cultural activities from 1951 to 1954 and MoMA's executive secretary in 1948–49, published an article in the May 20, 1967, *Saturday Evening Post,* "I'm Glad the CIA Is 'Immoral'" (Cockcroft, 40).
20. John Gash, "Rembrandt or Not?" *Art in America* 81 (January 1993), 62.
21. "Matisse: A Symposium," *Art in America* 81 (May 1993), 75.
22. Robert Storr, *Guston* (New York: Abbeville, 1986), 28.
23. October 25, 1970, B27.
24. Deborah Drier, "Cindy Sherman at Metro Pictures," *Art in America,* January 1986, 137.
25. Joanna Frueh, "Joy Poe," *New Art Examiner* 6 (June 1979), 8.
26. Interview with Joy Poe, ibid.
27. Letters, ibid., 8–9.
28. Alan Trachtenberg, "Contesting the West," *Art in America* 79 (September 1991), 118.
29. Brian Wallis, "Senators Attack Smithsonian Show," *Art in America* 79 (July 1991), 27.
30. Trachtenberg, 119.
31. Quoted in "Showdown at 'The West as America' Exhibition," *American Art* 5 (Summer 1991), 4, 6.

The Function of Artists in Society

Starving Celebrities and Other Myths

*The artist is not responsible to anyone. His social role is
asocial; his only responsibility consists in an attitude,
an attitude to the work he does.
The artwork comes into being in the artist's head, and it
stays in the artist's head. There is no communication
with any public whatsoever. The artist can ask no questions,
and he makes no statement; he offers no information,
message or opinion.
He gives no help to anyone, and his work cannot be used.*
—Georg Baselitz

A few years ago, while teaching at the Glasgow School of Art, I noticed growing conflict within the new graduate program. At a critique, a sculpture student presented small ceramic figures, lumps of unglazed clay, their surface a record of her hand, complete with fingerprints, accidental gouges, spontaneous stretches and bumps. She arranged this row of Willendorf Venuses carefully, attentive to the space between them, the lighting, and their place on a long narrow shelflike pedestal. Each figure glowed with an aura of her touch and personality. She returned to her seat and quietly waited for a response to their magic.

A photography student leaned forward in her chair, plainly impatient, irritated. "What do these little statues have to do with anything? They're self-

indulgent, irrelevant—the kind of thing rich people decorate with." The last words a sneer, the photographer leaned back, frowning, folding her arms. A friend of the sculptor noisily turned toward the wall where the photographer's work was spread austerely across twenty feet of space. Text had been neatly painted on the white surface; black-and-white images, enlarged from the front page of the *Glasgow Herald,* documented the decline of the city's shipbuilding industry. She said, "Her sculptures express feeling, personal feeling that connects with people, that then becomes universal—not trendy political propaganda." Pointing at the wall, she continued, "That stuff isn't art, it's politics and sociology."

As the four instructors and the painter of *Jacob and the Angel* show, and as belief systems show, artists are a diverse bunch, and the things called art have an amazing and perplexing lack of commonalty. Through their artworks, artists are engaged in a profusion of social activities; they are involved with an enormous variety of techniques, materials, forms, and meanings. Their work rambles over a vast territory of human purposes. An artist such as Donna Cox, who uses supercomputers as her medium, visualizes complex mathematical formulas. Adrian Piper engages in social criticism through her aggressive performance art and video. Bill Carlson sells his complex sculptures of laminated glass throughout the world. And Brian R. Kelly accepts commissions from architects for murals, mosaics, and relief sculptures, works integrated into the surface and structure of buildings. Because of the types of work they do, the different social roles these artists assume may have more in common with those of scientific researchers, manufacturers, journalists, or cabinetmakers than with those of other artists.

When artists make choices about what they want their works to do, they assume a social role, become a particular kind of social agent. In recent history, artists have assumed a variety of roles in society, directing their work to very divergent social ends. These divergent goals can be best understood if they are traced to various sets of assumptions about the artist's role in society. It is important to ask what social role for the artist is shaped and defined by a particular action we call "art." Or, to suggest a chicken-and-egg situation, from what social role does a particular action originate?

Artworks serve many distinct social purposes, and the diverse functions that artworks can perform in a society are well known, even if they are not clearly articulated. And without stopping to think about it, we privately, or perhaps even publicly, attach some hierarchy of value to the ways artworks operate socially. Conscious recognition of these various roles and their own sets of assumptions about art is immensely important. For artists and audiences who may be working with different assumed roles, it makes for clear communication and effective evaluation.

FIVE SOCIAL ROLES

The construction of historical models or paradigms is a practical way of discussing the social function of artists.[1] Before reviewing these models of the artist's social role, however, we must make some disclaimers. The five models that follow are an incomplete list meant to address the current practice of Western art, although these models are appropriate to much other art as well. It is also important to remember that, although these models have evolved over time, none of them is extinct. All are actively present in contemporary art, and most artists develop a complicated mixture of them. In addition, references to their historical roots are oversimplified, and since they are portrayed as historical paradigms, it should be clear that they cannot be ripped out of a historical context and adopted by today's artist in the *same* form in which they originated. Nevertheless, it is clear that the various social roles that artists have adopted and developed throughout our history are present in the contemporary art world, where they merge, mingle, and collide. While each model has some readily apparent social benefits, each also has some weaknesses, ways in which this or that artistic role is myopic, self-indulgent, or, at times, harmful. These strengths and weaknesses, these roles in all their mixtures and blends, describe some of the tensions in contemporary art.

These five models are curiously subject both to an exaggeration of their qualities and an exaggerated *reversal* of their qualities. Both forms of exaggeration result in stereotypes about artists that could be constructed as a complete set of conflicting myths of the artist. Each model, then, is accompanied by two related myths, the one an exaggeration of the model's qualities, and the other an extreme opposition to some quality of the model. These caricatures, because they are extreme and simplistic, continue to confuse and mislead both artists and their public.

The Artist as Skilled Worker

The role of the artist as a skilled worker, craftsperson, or artisan is best exemplified by Western art from the Greco-Roman through medieval periods. Greek temple sculpture and vase painting, Roman mosaics, and medieval manuscript illumination were done by artisans of low social status who rarely achieved any individual recognition. In fact, many of these artists are known only by their works, and in art history texts are given names such as the Master of the *Saint Ursula Legend,* the Master of the *Virgo inter Virgines,* the Boucicaut Master. This type of artist is trained in a manual skill, does a specific, narrowly defined job, or solves a problem—not a problem recognized as intellectual, but a physical, formal problem. In this view of the artist's social function as craftsperson, notions of "mastery" and "masterpiece" originated. Ideas, plans, programs, and schemes are suggested by

others and then carried out by the artisan. Because of its direct dependence on patronage, its origins as a commission, the artwork is necessarily part of a shared system of communal values.

In fact, this dependence is the source of the major tension of values in this paradigm. On the one hand, the artist and artworks are socially integrated; they contribute directly and productively to the society. On the other hand, such work is by nature conservative, stressing continuity and rules. It does not develop a critical relationship to its society but instead reinforces the social consensus. Perhaps more positively, however, no cult of originality develops among such artists—after all, many of the ideas for the work are not even initiated by the artist. This kind of art is created to serve others' interests. Some see this service to others as another danger in this role: the artist is subordinate, dependent on another's agenda. Artists merely end up reinforcing the status quo, like Norman Rockwell, industriously meeting the agenda of the *Saturday Evening Post*. But this *serving* can be argued more positively: As skilled workers, artists are responding to clear social needs; their work has the utility and necessity of carpenters' and bricklayers' work.

This view of the artist as a skilled worker is the pivot of two antagonistic myths that are very much a part of the public's understanding of artists. When the artist as skilled worker is idolized, we soon create its caricature: *artist as virtuoso.* Technique itself becomes the goal, and the flashier the technique, the better the work. Who has not been to an exhibition of realist painting and heard the viewers exclaim: "Look at all this detail!" "How does she do this?" "It must have taken a long time." In opposition to the skilled-worker model, we find another prevalent mythic role. This artist is a rule-breaker, a rejecter of any social integration. This is the myth of the *artist as anarchist.* Just prior to World War I, Dada writers and artists embraced this myth, relentlessly promoting both anarchy and themselves. Tristan Tzara begins one of his seven Dada manifestos, "Manifesto of Mr. Antipyrine," in this way:

> Dada is our intensity: it sets up inconsequential bayonets the sumatran head of the german baby; Dada is life without carpet-slippers or parallels; it is for and against unity and definitely against the future; we are wise enough to know that our brains will become downy pillows that our anti-dogmatism is as exclusivist as a bureaucrat that we are not free yet shout freedom—
>
> A harsh necessity without discipline or morality and we spit on humanity. Dada remains within the European frame of weaknesses it's shit after all but from now on we mean to shit in assorted colors and bedeck the artistic zoo with the flags of every consulate
>
> We are circus directors whistling amid the winds of carnivals convents bawdy houses theatres realities sentiments restaurants HoHiHoHoBang[2]

But these two extremes of virtuoso and anarchist, these myths, are not all that is left of this model today. The role of the artist as skilled worker persists. The Venetian glass artist Pino Signoretto has made work to the specifications of other

artists, such as Jeff Koons, whereby Signoretto's skills help realize an artwork credited to Koons. Professional potters who sell their work at art fairs, the painters of commissioned portraits, artists who make murals, mosaics, and stained glass for public spaces—these are all contemporary examples of the artist as skilled worker.

And the artist as skilled worker is around in another, more subtle form: *the artist as professional.* Professionalism has dominated all the arts in twentieth-century Western culture. A profession (whether that of artist, dentist, or lawyer) typically has the following characteristics: it is not seen as being the domain of amateurs; it has organized groups for members (such as the College Art Association); evaluating its activities and any accountability of its members are typically seen as being in the domain of other members of the profession; it has schools whose students are taught by certified members of the profession; it creates specialization and subspecialization of its activities; it employs a specialized critical vocabulary that is somewhat closed to general audiences; it sees its activities more as the function of a career than of a calling.

Most artists today share at least some of these characteristics of professionalism. Further, artists, with their historic attention to craftsmanship, teaching in the academies, and use of physical skills, have a natural affinity with professionalism, more natural than the practitioners of an art such as literature have. And professionalism is open to virtually all of art's social roles. Even an intellectual or a shaman can be a professional; only the naive artist seems by definition immune from professionalism.

The Artist as Intellectual

The artist's role as an intellectual became the new paradigm of the high Renaissance. Renaissance painters, sculptors, and literary humanists originated "the idea of the artist as an intellectual hero and the conception of art as the educator of humanity. They were the first to make art an ingredient of intellectual and moral culture."[3] Michelangelo, Leonardo, Raphael, and Dürer are some of the better examples of this model. In this view, art deals with important ideas, and the artist investigates all areas of human knowledge and contributes to them. This model has a high estimation of the artist and values the "artistic personality": Artists are inventors and discoverers. Artists engage in theoretical and analytical pursuits. One has only to look at the sketchbooks of Leonardo to understand this paradigm.

Although the obvious benefits to this model are the ways it advances knowledge and art (as, for example, in the color studies of Josef Albers), the traditional danger associated with it is that of elitism. Twentieth-century artists have all wrestled with this problem. The critic Suzi Gablik begins her book *Has Modernism Failed?* with this very subject. She quotes American sculptor David Smith's declaration that "nobody understands art but the artist, because nobody is as interested

in art, its pursuits, its making, as the artist." To that she adds, "From the start, the mystique of modern art has always been that it is not generally popular, or even comprehended, except by an elite few."[4] For example, the conceptual art, minimalism, and serialism of the late sixties, which fit this paradigm, became so inaccessible to any general audience as to be solipsistic. The work became self-referential and art-about-art. Artists wrote and spoke in a language as turgid and forbidding as Wittgenstein's. As the history of conceptual art demonstrates, when art becomes so theoretical that the audience shrinks to a very select group, art can become an act of exclusion.

This paradigm of the artist as intellectual is a point of reference for two other deep-seated myths of the artist. Already in the Renaissance, it was not enough for these artist-intellectuals to be thoughtful philosophers—they had to be geniuses. The great myth of *the artist as genius* arose out of the high Renaissance, when values of individuality and intellectual property developed from the weakening guild system and disintegrating Christian culture of the Middle Ages.[5] Giorgio Vasari's *Lives of the Most Eminent Painters, Sculptors, and Architects* (1550) was no small contributor to this exaggerated role. Vasari begins his biography of Leonardo:

> The greatest gifts are often seen, in the course of nature, rained by celestial influences on human creatures; and sometimes, in supernatural fashion, beauty, grace, and talent are united beyond measure in one single person, in a manner that to whatever such a one turns his attention, his every action is so divine, that, surpassing all other men, it makes itself clearly known as a thing bestowed by God (as it is), and not acquired by human art. This was seen by all mankind in Leonardo da Vinci, in whom, besides a beauty of body never sufficiently extolled, there was an infinite grace in all his actions; and so great was his genius, and such its growth, that to whatever difficulties he turned his mind, he solved them with ease.[6]

Moving away from the artist-intellectual, one finds a second prevalent myth: *the artist as naive innocent*. This artist is no intellectual but rather is a "natural" artist who may, of course, be a genius as well. This is the untrained artist, working away in ignorance of art history and technique and often in ignorance of contemporary culture as well. Perhaps the greatest modern example is Henri Rousseau. The poet and critic Guillaume Apollinaire described his friend Rousseau as "the splendid, childlike old man" who "had the great good fortune to incarnate, as fully as possible, that delicate, ingenuous, elaborate naturalness, combined with playfulness at once knowing and naïve." According to Apollinaire, Rousseau "painted with the purity, the grace, and the consciousness of a primitive," a primitive whose "paintings were made without method, system, or mannerisms." Implicit in this myth is the belief that formal training would destroy the power of the naive artist's work. Apollinaire writes that if Rousseau "had drawn these touching allegories by an act of will, if he had drawn these forms and colors according to a calculated, coolly elaborated system, he would be the most dangerous of men, while in fact he is the

most sincere and most candid."[7] In the twentieth century, educated artists turn more and more to folk art, children's art, and the art of the mentally ill to understand this natural, unselfconscious creativity. And the work of naive artists, such as Grandma Moses and the Reverend Howard Finster, are hung in the most prestigious galleries and museums.

The artist as intellectual remains a relevant paradigm in contemporary art. The work of Joseph Kosuth, for example, continues this role. Consider his early *One and Three Hammers* (Figure 3.1). This 1965 work consists of a hammer, which is set between a photograph of a hammer and a photocopy of a dictionary definition of a hammer. In his highly conceptual artworks, Kosuth explores theory, philosophical issues such as epistemology and ontology, and language. Many of the artworks consist only of words; the art is no longer an object, but an idea. As Kosuth himself claims, "It is impossible to see my work. What is seen is the presentation of the information. The art exists only as an invisible, ethereal idea."[8] More recently, the 1995 work *Unpacking My Library,* by Buzz Spector, connects the theories of Walter Benjamin and his ideas about collecting with Spector's own meditations on the relationships of books and art, texts and images, relating public history and private memory. The work consisted of 4,051 books, the artist's complete personal library, arranged in order of height on an uninterrupted shelf, completely circling the gallery. Or consider his *Freeze Freud* (1992), the complete works of Freud embedded in a 700-pound block of crystal clear ice inside a glass-doored supermarket freezer case (Figure 3.2). It provocatively raised questions about authorship and identity and how the complete output of a writer is the "body of his work."

The Artist as Entrepreneur

By the time of the Baroque period, an art market directed toward most social classes developed. Free from the patronage of the church and aristocracy, the artist looked to the rising middle class for support. In the seventeenth-century Netherlands, this art market was so well established that works were bought and sold for investment purposes. The Dutch genre painters epitomize this new model of artist as entrepreneur, an independent agent living off the sale of artworks. In some cases, such as Rubens, the artist is immensely successful, employing a whole workshop of artists to turn out pieces done under his supervision. In the marketing of artwork, a personal style becomes very important: it identifies the product and helps control supply and demand.

This paradigm of the artist as a kind of businessperson has some obvious strengths and weaknesses. The artist's independence is clearly beneficial—the artist is free to develop ideas and objects. But of course, this benefit is balanced by the fact that these objects must be bought and sold, and that they must necessarily be *objects*. And herein lies the new control: Instead of having to please the church and aristocracy, artists have to please the market. For example, look at the bankruptcy

Figure 3.1 Joseph Kosuth, *One and Three Hammers* (English Version), 1965. Hammer, photograph of a hammer, photostat of the definition of hammer, 24" × 55³/₈". (© 1997 Joseph Kosuth/Artists Rights Society [ARS], New York.)

Figure 3.2 Buzz Spector, *Freeze Freud,* detail, 1992. Installation. Books in ice in freezer cabinet. (Artist's collection. Photo © Adam Reich.)

of Rembrandt, the poverty of Frans Hals. The artist becomes only too aware of the demands of selling, and these demands affect every aspect of the work's production—from its materials to its subject matter to the beliefs it promotes. This is the danger of commercialism, the tailoring of aesthetic decisions to the tastes of the buyers. As the critic Lucy Lippard states about art at the beginning of the 1980s, "The illusion of the new, like that of obsolescence, is fostered by competitive commercial interests."[9] The market, more than creativity itself, encourages the process of changing fashion.

This independent, entrepreneurial artist is perhaps more interested in fame than any other of the artist types is. Personal celebrity helps sell the artworks. And here is the origin of another of the great mythic artist roles: *the artist as independent hero.* These artists are courted by the press, the government, and art institutions. Rubens defined this role, David perfected it, Picasso lived it completely, and Warhol parodied and exploited it to its highest level. In fact, Warhol's art was about this myth. But side by side with this caricature of the artist is another: *the artist as economic failure.* This is the myth of the starving artist. No artist has been more completely stereotyped into this role than Van Gogh, painting soul-haunting masterpieces while bleakly eating mealy potatoes in a dingy hovel. Countless artists simultaneously envy the famous misery of Vincent and the heroic celebrity of Pablo. They forget that during an artist's lifetime the two roles are mutually exclusive; only at death can they possibly merge.

Who are the entrepreneurs of today? For the best examples, look through the back-page advertisements in *ARTnews.* But, of course, in our economic system, most artists participate to some degree in this social activity. Keith Haring and Mark Kostabi made interesting additions to it: Haring with his own commercial distribution network, Kostabi with his production techniques borrowed from industry. Perhaps the most breathtaking example of an artist-celebrity-entrepreneur is Helen Frankenthaler, selling her image as a famous artist to Rolex to help them peddle watches. The full-page color ad, which ran in *Art and Antiques,* concludes: "'I've explored a variety of directions and themes over the years. But I think in all my painting you can see the signature of one artist, the work of one wrist.' And on that immensely talented wrist, Helen Frankenthaler has chosen to wear a Rolex."

The Artist as Social Critic

The nineteenth century saw the first major emergence of the artist as social critic. In this model, art is a means of human liberation, a tool in the struggles against injustice, a way to transform the world. This model developed out of the French Revolution and the romanticism of the early 1800s. By the end of that century, many artists were taking the role of alienated expatriate, a kind of prophet who stands outside society. Perhaps evolving out of the earlier myth of the artist as independent hero, this role has artists setting their own values, values very much apart

from those of the society at large. So, starting with the revolutionary social criticism of artists like Goya, this model develops through the defiant bohemian artists of early-twentieth-century Paris to the postmodern social-activist artists of the present. These artists create new visual languages in order to reject particular social and aesthetic conventions.

What are the attractions and problems associated with this paradigm? These artists, like many other people, are outraged by injustice and see their artwork as a vehicle of change. But this social relevance often runs counter to values embedded in other models. For instance, art that is directed at specific current issues often lacks the marketable eternal beauty the artist-entrepreneurs seek to imbue their commodities with. Some artists will accuse socially critical works of didacticism or a lack of the kind of ambiguity essential to art. In the extreme, socially critical artists are accused of doing sociology, not art.

For example, the predominantly textual works of Hans Haacke make little attempt to operate within the tradition of the aesthetic object; instead, primarily through text, they expose hidden (and perverse) power relationships, particularly relationships between museums and big business. Haacke's 1974 *Manet PROJEKT '74,* initially intended for the exhibition "Art Remains Art" at the Wallraf-Richartz Museum in Cologne, illustrates the tensions produced by such art (Figure 3.3). Haacke's work consists of Manet's *Bunch of Asparagus*—owned by the Wallraf-Richartz—and a series of panels placed next to it. Haacke's general outline for the project proposed that these panels would include text that would "present the social and economic position of the persons who have owned the painting over the years and the prices paid for it." These panels create the work's power and its danger. Haacke is aware of these complexities; he argues that a major difficulty in making this kind of socially critical art is the constant threat of co-option by the system: "One of the problems one faces, when one has become aware of the interconnectedness of the art world and the social world at large, is how to function without, in effect, affirming power relationships with which one does not agree."[10] The relevant power structure in the case of the *Manet PROJEKT '74* was the museum's board of directors. It objected to Haacke's final panel. In it, Haacke listed Hermann J. Abs, the person who had acquired the Manet for the museum, citing Abs's nineteen positions on corporate boards of directors and his questionable history during World War II. The letter of rejection sent to Haacke by the directors of the museum argued, "A museum knows nothing about economic power; it does, indeed, however, know something about spiritual power."[11] In this arm-wrestling match between art as sociology (as a wielder of power) and art as eternal truth, eternal truth wins.

More recently, Mike Kelly exhibited a disquieting work at the University of Chicago, a piece called *Pay for Your Pleasure* (1988). It consisted of a hall lined with forty-three banners depicting famous "geniuses," great thinkers of Western culture, and culminated in a naive-kitsch self-portrait, *Pogo the Clown,* painted in prison by the mass murderer John Wayne Gacy. Referring to a traditional portrait

Figure 3.3 Hans Haake, *Manet PROJEKT '74,* 1974. Ten panels, each 20½" × 31½", color photograph of Manet's *Bunch of Asparagus,* with frame (actual size), 32¾" × 37".

gallery, the work questioned the relationship between art, culture, and criminality.

This paradigm of the artist as social critic can also be taken to extremes. One of the great myths is *the artist as social outcast,* as exile, as bohemian. This myth has its roots in Renaissance individuality, but came to its climax with nineteenth-century romanticism and its emphasis on the inseparability of art and life. These artists make a social statement not just with their art but with their lifestyle. They are either internal émigrés, living in but staying aloof from their culture, or they flee like Gauguin to remote cultures. But as the art historian Arnold Hauser says, "both are the product of the same feeling, the same 'discomfort with culture.'"[12] At the present, this myth of the artist as social outcast is more pervasive than any other. Paradoxically, the attempt at social nonconformity among art students is so predictable as to be the established rule.

But this paradigm of the artist as social critic also has its evil twin, its negative construction. This is the myth of *the artist as social parasite.* A major rhetorical function of this myth is the devaluing of artists' activities—usually by groups threatened by some artist's social criticism. This denigration knows no ideological bounds; it is a kind of common slander, a general slur to minimize the importance of artists and therefore their criticism. In this caricature, artists make no real productive contribution to society; rather, in their self-indulgent excesses, they sponge off the society at large. This attitude is common in the ongoing fights over the National Endowment for the Arts budget legislation.

In 1984, Lucy Lippard wrote that in contemporary art "there is a renewed sense of the power of culture to affect how people see the world around them."[13] This perception that art has the ability to change the world ensures that the model of the artist as social critic remains prominent in today's art world. Martha Rosler, Barbara Kruger, Jenny Holzer, Leon Golub, Nancy Spero, Thomas Lawson—the list seems endless.[14]

The Artist as Social Healer

Some artists believe their work can express transcendent truths that accomplish social healing. They try to operate as priests, mediating between people and the harshness of the physical, social, and spiritual environment. In this role, artists have an important function as leaders in social, political, and religious rituals.

The best historical precedent for this is the shaman, what educator/aesthetician Edmund B. Feldman describes as "a combined sorcerer, healer, priest, psychiatrist, magician, artist."[15] This model is rooted in a prehistoric role that is not primarily, by Western standards, artistic but religious. Thus it is a role that is first of all concerned with human relationships: to others, to nature, to God. It attempts to mediate these relationships and to create a healthy future. But the term *shaman* translates uneasily to contemporary society. Most contemporary artists who indulge in shamanic rituals do so without any supporting community in which these works

function. They are merely engaged in pseudo-rituals, operating out of no shared system of belief. Further, the objects that historically have resulted from shamanic or other ritual activities are not art objects in any modern, traditional, Western sense. These things should not be merely contemplated for aesthetic values while ignoring their purpose, their ritual context. So in the model of artist as social healer, the term *shaman* should probably be understood as metaphorical.

In 1967, Bruce Nauman made a spiraling neon artwork which, perhaps facetiously, stated "The true artist helps the world by revealing mystic truths" (Figure 3.4). The age-old myth of *the artist as mystic* is the more extreme statement of the paradigm of the artist as social healer. Many modern artists have directed their work toward transcendent, spiritual goals and exemplify this particular mythic role: Piet Mondrian, Mark Rothko, and Barnett Newman are a few. According to Newman scholar Thomas Hess, when Newman spoke or wrote about his work "it would be in terms of absolutes, the Sublime, the Tragic (words that demand capital letters which, in conversation, he invoked with his index finger pointing to the sky, palm turning inward, the characteristic Augustus Caesar gesture)." Hess goes on to explain that in viewing Newman's work, the spectator has a spiritual experience:

> The spectator, like the artist himself, would encounter these metaphysical forces through the medium of the painting in a mysterious, perhaps empathetic, perhaps archetypal contact. . . . From the artist's and the spectator's comprehension of the experience emerges insights to the Tragic and the Heroic—a meeting with Absolutes, with the spiritual.[16]

Suspicion of the healer and magician, and perhaps some actual evidence, has developed into a notion of *the artist as charlatan,* the trickster, the fraud, the quack. For example, the artist who most often has been labeled an artist-shaman, Joseph Beuys, has also been frequently accused of being a charlatan. These charges question the truth of Beuys's account of his formative war survival experience, the subject of so much of his work. According to the legend that Beuys promoted, when as a German pilot in World War II he was shot down over the Crimea, he was saved by Tartar nomads who wrapped his wounded body in healing swaths of fat and felt. This incident became the material and subject of much of Beuys's work, such as *The Pack,* a Volkswagen bus followed by twenty sleds, each one loaded with felt, fat, and a flashlight (Figure 3.5).

The role of artist as social healer can take many directions. Consider the contrasting examples of Anselm Kiefer and Mierle Laderman Ukeles. Kiefer, a German artist, makes objects that fit comfortably into a Western tradition of painting as autonomous object, but they are objects that deal with German history and that synthesize the past and its metaphors of devastation into the hope of regeneration. Suzi Gablik says Kiefer "is one of the few artists working today who opens up the vision and ideal of apocalyptic renovation and makes the effort to regain the spiritual dignity of art."[17] Ukeles has been the unsalaried artist-in-residence at the

Figure 3.4 Bruce Nauman, *Window or Wall Sign,* 1967. Blue and peach neon tubing, 59" × 55". (© 1997 Bruce Nauman/Artists Rights Society [ARS], New York.)

Figure 3.5 Joseph Beuys, *The Pack,* 1969. Volkswagen bus with twenty sleds, each carrying felt, fat, and a flashlight; dimensions vary. (©1997 Artists Rights Society [ARS], New York/VG Bild-Kunst, Bonn. Photograph by Mary Donlon © The Solomon Guggenheim Foundation, New York.)

New York City Department of Sanitation. Her performances and installations are an empathetic affirmation of the sanitation workers. In another article, Gablik says Ukeles's work "uses shamanic means in a modern way. We can see how the model of a shaman strikes at the roots of alienation—in merging her consciousness with the workers, she converses with them, learns from them, and becomes one with them."[18] These artists share strong overtones of a healing role and a priestly mediation, Kiefer with the tragedy of modern Germany, Ukeles with the day-to-day humiliation of sanitation workers.

In 1993, the Chicago collective Haha created the work *Flood: A Volunteer Network for Active Participation in Healthcare* for Sculpture Chicago's "Culture in Action" project (Figure 3.6). Haha organized and set up a hydroponic garden in a storefront. This garden served as a center for AIDS issues, where the metaphor of the garden as a nurturing place created a space where an overwhelming social problem could be approached in a nonconfrontational way.

IMPLICATIONS OF SOCIAL ROLES

For the art community, what are the implications of looking at art and artists in terms of social roles? First, if we recognize that all of these models are present in contemporary art, then we are obliged to distinguish these various social activities when we either make or evaluate art, even though they can be mixed together in different combinations. Each model has specific and unique goals, and therefore specific and unique obstructions and difficulties. Some evaluative criteria may be common to all, some unique to one. Work done on supercomputers to visualize complex mathematical formulas has evaluative criteria far different from those of socially critical performance art and video. But what about the less obvious differences between laminated glass sculptures and mosaics? Here the artworks themselves do not announce their differences; a fuller understanding of the works' uses and these uses' relations to the artists' intentions is necessary. In all cases, however, one cannot properly evaluate artworks if one is not clear on the social actions out of which they arise. Furthermore, the social activities themselves should be open to critique. Are we free to assume that all of these models are equally valid for contemporary art? Should we promote some as more worthy than others? What are the criteria? These questions must be dealt with openly, explicitly, not camouflaged by unexamined assumptions of personal taste.

Finally, questions need to be asked about the grand myths associated with each of these paradigms—those heightened exaggerations and those shadowy, reactive stereotypes. Are they true? Are they useful? Or does the uncritical acceptance of them hinder the social actions of artists? The virtuoso, the genius, the independent hero, the social outcast, the mystic, the anarchist, the naive innocent, the economic failure, the social parasite, the charlatan—all of these myths potentially do a

Figure 3.6 Haha and Flood, *Flood: A Volunteer Network for Active Participation in Healthcare*, 1993. Sculpture. (© John McWilliams.)

disservice to artists. For example, when artists complain about their low income, they resent the response that artists are supposed to suffer. *The Agony and the Ecstasy* and *Lust for Life* may be good stories, but their contribution to these mythic understandings of the artist have not helped. Since these myths are so deep-seated and so widespread and so at odds with what *real* work demands, how do artists convince others that artists participate in society, that their activities are social activities bound together with the work of others, that their work is relevant?

The myths draw attention away from what artworks can achieve by focusing too much on the artist, and even then, they are as easily used to dismiss artists as to praise them. But even worse, they undermine the very activity of artists by stereotyping their actions and then directing these stereotypes back at artists, with the consequence that artists too easily adapt their lifestyles and their work to these myths. The creation of these myths is an act of cultural appropriation, a process of abstraction in which, as Hal Foster explains, these myths then serve as "substitutes for active social expression and as alibis for consumerist management."[19] The myths, in the end, encumber and begin to regiment what artists do, and then the work is further caricatured, controlled, and either shoved aside or reprocessed back into more myth.

Artists are engaged in social actions. These social actions are extremely diverse, and the works produced by them are directed toward a multiplicity of ends. Stereotypes to the contrary, artists are not so different from scientists working on bird migration, reporters for the *Cleveland Plain Dealer,* Amish cabinetmakers, or manufacturers of bedside reading lamps.

NOTES

1. In the following, we have relied on a number of works by others, including Arnold Hauser, *The Social History of Art* (London: Routledge & Kegan Paul, 1951) and Edmund B. Feldman, *The Artist* (Englewood Cliffs, N.J.: Prentice-Hall, 1982), although most of what we have to say here has grown out of discussions in graduate and undergraduate seminars. Our choices of historical models and their labels bear a superficial resemblance to much of Feldman's historical outline, but our purposes are somewhat different. Feldman traces the evolution of artist types "to demonstrate continuity and change among artists—in training and work, in cultural function, in patterns of patronage, in social recognition, in personal ambition, and in economic reward" (vii). We are interested in how a set of historical models of artistic roles can describe the tensions in today's art world, how they reveal the various conflicting myths of the artist that are prevalent in our time, and how they each demand their own criteria for discussion.

2. *The Dada Painters and Poets,* ed. Robert Motherwell, Documents of Twentieth-Century Art series (New York: Wittenborn, Schultz, 1951), 75.

3. Hauser, 340.

4. Suzi Gablik, *Has Modernism Failed?* (New York: Thames and Hudson, 1984), 12.

5. Hauser, 327.

6. Giorgio Vasari, *Lives of the Most Eminent Painters, Sculptors, and Architects,* trans. Gaston Du C. de Vere (New York: Abrams, 1979), 778.

7. Guillaume Apollinaire, *The Cubist Painters: Aesthetic Meditations, 1913,* trans. Lionel Abel, Documents of Modern Art series (New York: Wittenborn, Schultz, 1949), 39, 40. "The Douanier," *Apollinaire on Art: Essays and Reviews, 1902–1918,* ed. Leroy C. Breunig, trans. Susan Suleiman, Documents of 20th-Century Art series (New York: Viking, 1972), 336, 339, 348.

8. Quoted in David L. Shirey, "Impossible Art: What It Is ('Thinkworks')," *Art in America,* May 1969, 41.

9. Lucy R. Lippard, "Sex and Death and Shock and Schlock: A Long Review of 'The Times Square Show' by Anne Ominous," *Artforum* 19 (October 1980), 54.

10. Quoted in Jeanne Siegel, "Hans Haacke: What Makes Art Political," *Artwords 2: Discourse on the Early 80s* (Ann Arbor, Mich.: UMI Research Press, 1988), 68.

11. Quoted in *Hans Haacke: Unfinished Business,* ed. Brian Wallis (New York: New Museum of Contemporary Art, 1986), 118–33.

12. Hauser, 891.

13. Lucy R. Lippard, "Trojan Horses: Activist Art and Power," in *Art After Modernism: Rethinking Representation,* ed. Brian Wallis (New York: New Museum of Contemporary Art, 1984), 341.

14. Leon Golub says, "Everybody knows artists don't change society, but that's too easy a way to put it. Artists are part of the information process." Quoted in Jeanne Siegel, "Leon Golub: What Makes Art Political," *Artwords 2,* 61.

15. Feldman, 2.

16. Thomas B. Hess, *Barnett Newman* (New York: Museum of Modern Art, 1971), 16–17.

17. Gablik, 124.

18. Suzi Gablik, "Deconstructing Aesthetics: Toward a Responsible Art," *New Art Examiner* 16 (January 1989), 34.

19. Foster, *Recodings,* 168.

Art and Its Audience

The Woman with Four Toes

I want to be invited to the White House.
— Jeff Koons

In 1928, Charles Holden, a respected English architect, commissioned the sculptor Jacob Epstein to do two large carvings directly above the main entrances of the new Underground Electric Railway Company Building in London. This was not the first time Epstein had worked for Holden. Twenty years earlier Holden had commissioned Epstein to carve eighteen larger-than-life-size figures on the headquarters of the British Medical Association. The uproar over those nude figures had nearly resulted in their destruction, and led to a spirited vilification of Epstein in the press. According to Epstein, Holden was therefore circumspect this time, sneaking Epstein into the construction site by introducing him to the Clerk of the Works as "the sculptor" for fear "'dark forces might upset things.'" Epstein commenced carving two figurative works, *Night* and *Day*, whose formal energies lay in Mexican and Greek archaic sculpture. As Epstein describes it, "of course my work astonished the men on the building, and many a facetious remark was passed. . . . I had a shed built around my work."[1] Facetiousness was the least of Epstein's worries. While he did have some defenders in the press, more typical was the *Manchester Guardian*'s grumbling against "The Cult of Ugliness" and the *Daily Express*'s complaint that *Night* was a "prehistoric, blood-sodden cannibal intoning a horrid ritual over a dead victim."[2] Vandals, dressed in plus fours, drove by *Night* and splashed it with tar and feathers. Two thousand students rallied on the steps of the building on Guy Fawkes Night to protest the work.

More effectively, angry shareholders of the Underground Company succeeded in calling a board meeting to discuss the work and its possible removal. At this meeting, Lord Colwyn, a cotton and rubber magnate, persuaded the board of directors to take down the sculptures and replace them with ones Colwyn would pay for. In order to delay the removal, a supporter of Epstein threatened to resign, and the two sides entered into some murky negotiations, with the following compromise: After Holden had an emergency meeting with Epstein, *Day*'s scaffolding was put back up, Epstein climbed it, and lopped off an inch and a half from the sculpted boy's penis (Figure 4.1).[3]

Some of the most famous art stories are not stories about artists, not stories about artworks, but stories about audiences. The term *stories* appears here deliberately, for not only official art history but art gossip is full of stories of interactions between artists and their audiences. Examples from the lives of the nineteenth-century artist Gustave Courbet and the turn-of-the-century artist Henri Rousseau illustrate some of the range of these stories.

Throughout his career, Gustave Courbet, although lionized by some radical elements of French society, had a prickly relationship with the much larger part of his audience, the bourgeoisie, which was then comfortably in political power and exerting a conservative influence on French culture. Courbet's radical political views, his realism, and the explicit sexual content of his work formed a single, offensive package for this contemporary audience. It is said that the Emperor Napoleon III, playing Jesse Helms to Courbet's Mapplethorpe, was so infuriated by Courbet's *Baigneuse* of 1853 that he struck at it with his riding crop.[4] Courbet's work so outraged some segments of his audience that caricaturists could make money by depicting him as a charlatan. A caricaturist who worked under the name of Cham made a drawing of Courbet saying "There is a bourgeois stopped before my picture. He is not having a nervous attack. My show is a failure."[5]

With that context for his work, Courbet's two most scandalous paintings of the mid-1860s did not enter public discourse noiselessly. *Sleep,* for example, is a frankly male-oriented depiction of two female lovers in postcoital slumber. Dressed up with a few classical conventions (such as its stylized pose, drapery, and grand scale), the work was clearly intended to skirt the borders of pornography. It was commissioned by Kahlil Bey, a Turkish diplomat who had a reputation both for art collecting and high living. *Sleep* was so scandalous that when it appeared in the window of an art dealer six years later, its presence was duly noted in Courbet's police file. Why the police? Not just because of the work's flirtation with pornography, but as evidence of Courbet's radical politics. During a brief change in government, Courbet had been identified as the person most responsible for the politically motivated destruction of the imperial Vendôme column, and a painting such as *Sleep* gave further evidence of Courbet's degeneracy. In 1866, the same year that he painted *Sleep,* Courbet was again commissioned by Bey, this time to paint the even more scandalous *Origin of the World.* It is a close-up view of a woman's genitalia, with

Figure 4.1 Jacob Epstein, *Day,* 1928. Portland stone, 97" × 97" × 39". London Underground Electric Railways Headquarters, Westminster.

a highly foreshortened torso and right breast in the background. Bey apparently hid the work behind a green veil, and later replaced the veil with a panel depicting a castle in the snow. But the audiences for this explicitly pornographic work are probably more interesting than the work itself. Like all of Courbet's art, *Origin* had its supporters, such as the reputable critic Edmond de Goncourt, who declared that the belly of the figure "was as beautiful as the flesh of a Correggio."[6]

The audience for *Origin of the World* changed over the years, for in 1868 Bey's high living caught up with him. He was bankrupted by gambling debts and had to sell off his art collection. The painting disappeared during World War II and after the war was sold in Paris to an unknown buyer. Its audience after this point is worth noting: Apparently, it hung in the country house of Jacques Lacan, the renowned French psychoanalyst and academic. There, the painting was hidden by a wooden device made by the artist André Masson. The device represented an abstract version of the painting underneath, and if one knew the secret by which the device worked, one might slide it off to view the Courbet.[7] In 1995 *Origin* was donated by Lacan's heirs to the Musée d'Orsay in Paris, where in June of that year it was displayed behind glass, and given its own private guard.

The audience for Courbet's work is extremely diverse. For these two paintings in particular, the audience consisted of a libertine diplomat, visitors to his home, a caricaturist and the readers of the newspapers that published his drawings, an emperor, the police, those who casually passed by the gallery where *Sleep* was displayed, a cultural critic, an unknown owner, a famous psychoanalyst, his guests, a well-known painter, museum-goers, and a security guard. Further, these people's extremely odd and nervous interactions with these paintings do not epitomize what one might think of as the typical interactions with nineteenth-century painting. Courbet's work has been beaten, veiled, covered up, considered as evidence of criminal activity, and compared to the work of another master for its formal qualities.

But, as the following story will show, the multiple identities and functions of Courbet's audience only begin to suggest the range of audiences for art. Early in the twentieth century, Henri Rousseau had as his most engaged audience the avant-garde painters of the time, who viewed his extreme innocence both as the source of his powerful painting and as the opportunity to make him the butt of jokes. The culmination of this ambiguity was reached when Pablo Picasso invited thirty guests to his Paris studio in November 1908 to hold a banquet in honor of Rousseau. The banquet is legendary, and its famous participants have told the story numerous times, and in numerous ways. The guest list included Georges Braque, Gertrude and Leo Stein, the writers Guillaume Apollinaire and Max Jacob, the critic André Salmon, several unidentified American tourists, and the artist Marie Laurencin, who got covered with jam. Someone hung a large banner inscribed with the words "Honor to Rousseau," and Rousseau's *Portrait de Mlle. M.*—which Picasso had recently purchased from a secondhand dealer for five francs—was decorated with banners and mounted on the wall. Rousseau himself, seated on a makeshift throne on a jury-rigged platform, fell asleep several times during the evening, and seemed

not to notice the lantern above him, which over the course of the evening dripped a cone of hot wax onto his forehead.[8] The composition of Rousseau's audience clearly differed from that of Courbet's, as did its activities—with Rousseau, one observes an interaction with the artist that is neither hostility nor scandal, but something more ambiguous and perhaps more powerful.

Artistic identities are complicated. Courbet and his works are inseparable from his audience. Not just Courbet and his paintings, but also the French police, the Turkish diplomat, and the late-twentieth-century psychoanalyst are part of art history, and they are part of the same story. As for Henri Rousseau, the legend of his banquet is subject to wildly contradicting interpretations, ranging from seeing it as total mockery to real homage. The differences among the banquet stories (such as disagreements about the nearsighted Marie Laurencin's activities, and whether or not André Salmon and Maurice Cremnitz had a real fight or whether they just chewed soap and pretended to have a seizure) betray artists' anxieties about Rousseau as a doltish figure of fun or venerable savage, or both. But one thing is stable: The complicated energies arising from the response to Rousseau's naïveté—energies that make him both a great painter and a figure of fun—define not only how Rousseau's work is seen, but has come to color the reception of all naive artists in this century. For the purposes of this chapter, the point is that who we think of as Rousseau isn't just Rousseau the individual, or this individual and his work, but the two *combined with* their audience. The question we will begin to answer is simple: What happens when people see art?

RESISTANCES TO TALKING ABOUT AUDIENCE

But why should an artist be interested in what an audience thinks (that is, be interested beyond an anecdotal level)? This question needs to be clarified by the following reminder: The interactions that result from art-making are complex, a three-pointed relationship among artist, artwork, and audience. In that relationship, the social role of the artist is not completely defined by the artist and the sort of work she makes; what needs to be added is the *audience* to which that work is directed. In her role as entrepreneur, Helen Frankenthaler does not direct that role at her work, she uses her work to create a type of interaction with an audience, an interaction that might make her full-page magazine ad for Rolex watches shocking, but not surprising. That addition of an audience allows her to function in the role of artist as entrepreneur. Even the most extremely self-absorbed, egocentric art fills a social role. Julian Schnabel's narcissism is made interesting to others, and his work is interesting to others, only as an effective instance of a social role or some amalgam of social roles.

Without looking at the effect of an audience, then, understanding of the art process is incomplete. This chapter examines some typical ways by which audiences

shape the interaction through *their* social roles and beliefs; it looks at what audiences do to shape the content of art. This chapter will argue that what an audience *presupposes* and *does* changes what it *sees.*

That argument is not an automatic one, for art culture—particularly art culture within academia—has had some built-in resistances to talking about audience, resistances that make a difference for how artists think about their art. One can begin by noticing the observation made at the beginning of this chapter, that ideas about audience typically exist in a deflected form, as gossip. The fact that the stories of Courbet and Rousseau are not just history, but also gossip and folk legends, is important, for gossip and folk legends don't easily reveal their function or their importance. These are *stories* about audiences, not logical propositions about, or schematic conceptualizings of audiences. This distinction begins to explain why there are as many different versions of the Rousseau banquet as there are tellers, and why Gertrude Stein's version differs from the above version, recounted mainly through Fernande Olivier. They are not structured to reveal logical inconsistencies or the presuppositions operating behind them. So the best question may not be *did* Marie Laurencin get covered with jam, but what might it *mean* that Marie Laurencin got covered with jam? But it is not the sort of question that gets asked very often.

The gossipy form of personal history that characterizes much discussion of art audiences has a shadowy presupposition. It characterizes art as being essentially self-expression. There is a deep resistance to significant discussion of art audiences: a predisposition to deny that the audience is essential to art. Audiences, along with many other characteristics of art, are seen as secondary to self-expression. This retreat of art into the self doesn't encourage the mentioning of either the social roles of art or the object of that role: audience. But these two aspects of art-making do at least as much as self-expression to govern art production. A discussion of Diego Rivera's work misses something if it doesn't include an awareness of the urban audience he painted for, or the socialist revolution he wished his paintings to participate in, or the wealthy patrons (such as Henry Ford) who would at times commission his work.

What are the sources of the idea of art as self-expression, and what characteristics of this idea push art-making away from considerations of audience? A standard claim of art historians is that self-expression is a very Western phenomenon in art, a phenomenon whose primary source and first formulation lie in romanticism, a philosophical and aesthetic movement which in Western culture gained precedence during the early nineteenth century. Before this, there was a predisposition not so much to discount the artist's self-expression as not to see it at all, and to see art as doing something that represented the world, affirmed a belief, or perhaps idealized a person, a nation, or a form of government. Louis David's *Coronation of Napoleon and Josephine* (1805–7) is a classic example. Its monumental size and subject matter exist to glorify Napoleon, not David. Contrast that work and the

equally monumental works of Jackson Pollock, where the size and subject matter exist to display Pollock. When Pollock claims "I am nature," the striking and productive part of that claim is its self-assertion, the capital *I*.

Romanticism characterizes itself as opposing a view of art-making that obscures self-expression, and it seeks to make the artist the glitzy part of the art process. In rhetoric that stifles discussion of audience, most forms of romanticism stress the work of art as the product of the solitary individual, frequently at odds with his or her culture. A conventional trope is that the romantic artist paints for (or speaks to) himself, or perhaps a few other anonymous souls, and paints out of an urgent inner need, and paints that which cannot be spoken of in a social setting because it is too private. Social expression, which in this view is inherently tainted by compromise and unoriginality, *devalues* the private. (The current equation of self-expression with honesty is surprising for an age supposedly steeped in Freud and theories of self-deception. This instinct against the social has had a long shelf life.) Finally, in the romantic view of art-making, the *act* of painting (or of writing) is in itself enough. According to the romantic myth, what happens after the work is born is incidental.

Such a version of self-expression, when applied to the twentieth century, meshes with many characteristics of contemporary art, and consequently makes it difficult to imagine art as anything but self-expression. The most obvious characteristic may be the cult of originality. An idea central to modernism and the avant-garde, the fascination with and privileging of originality creates problems for moving art beyond self-expression. In Western culture, innovation in art is always associated with individuals, hence the traditional uneasiness among scholars about the beginnings of cubism, probably modernism's most significant innovation, which cannot be attributed to one artist.

The twentieth century also accentuates self-expression through the way art contacts the public. Art is typically marketed as individual works, and this calls attention to the work's creator. Many ads in art magazines don't show the artwork, they show the names of the artists. Names, artists, are for sale. Even prints are numbered to keep their individuality prominent, which has the consequence of keeping their prices up, under the principle that individuality corresponds to rarity.

What about strategies in Western art for ending the cult of originality and its emphasis on the individual artist by getting rid of self-expression? Some artists have resisted originality and self-expression by playing down the presence of their hand, the individuality of expressive mark-making. Pop art, appropriative art, photo-realism, geometric abstraction, aleatory art, conceptual art, and serial art all contain examples of this strategy, which perhaps reaches its apex in Sol LeWitt, who has other people do his drawings.

But this wish to rid art of self-expression is always somehow subverted, even in postmodernist art that strives most aggressively to either remove the presence of the individuality of a creator or to have an audience be an essential part of the com-

pletion of a work's meaning. For example, in 1989 the artist Stephen Prina did an exhibition called "Monochrome Painting" in which all the works were painted by a Los Angeles auto body shop. Thus, while there seems to be no sense of the artist in the slick, often technologically applied surface of these works, the expression of the self does occur in the *selection* of the subject, materials, content—and body shop. There is a sense of the artist's mind at work in the choice of what to represent. And art-magazine reviews of this kind of work more often celebrate the selecting mind than the actual selection. For part of her career, Sherrie Levine reproduced famous artworks. While these works of Levine's challenge the authority of the art object by being imitations, one couldn't recognize them as imitations without recognizing that it is Levine, not the original artist, who created these works and attached her name to the exhibition. After all, she showed and advertised them as *her* work. These sorts of paradoxes are rampant. Who exploited self-expression more than Andy Warhol, arch-entrepreneur who sold his personality? While Warhol's technique could (and often was) done by employees, these works' aesthetic principles have the Andy Warhol stamp. Similarly, although Sol LeWitt sends instructions to people to draw on gallery walls, the resulting works are still marketed as Sol LeWitt.

Some forms of collaborative art are also strategies of resistance to Western culture's excessive stress on individuality. As the critic Irit Rogoff argues, a group such as Guerrilla Girls guards the identity of its members partly out of pragmatic motives related to their criticism of the art world in their work, but also "as a radical strategic gesture against the invisible reconstitution of the artist as 'subject' and the extreme ways in which women artists, in particular, have been subject to demeaning narratives which equate biography with the work produced"[9] (Figure 4.2). Other groups such as TODT also value anonymity and find it to be a source of power. As the curators for the exhibition "Team Spirit" claim, "Its anonymity affirms that it is already beyond whatever could name it."[10] Yet TODT has a name, and a success that derives from how effectively it has defined itself as a group and identified its work as its "product," an expression of its beliefs.

In addition to certain *genres* of art, there are certain *social roles* that mute self-expression's dominance. For example, the artist as skilled worker does not engage primarily in self-expression. The architectural mosaics of Brian R. Kelly express the purpose and history of the buildings they decorate; rarely do viewers think about who made the mosaics. But even here the playing down of self-expression is militated against by the art community, which doesn't automatically think of the objects produced by such artists as art. Maybe audiences are so accustomed to thinking of art as individual self-expression that they overlook, as art, objects that don't follow this model, particularly those that are typically presented as anonymous: design (objects that are mass-produced) and crafts such as quilting (objects made by artisans who have had little connection to historical definitions of high art).

In contemporary art culture, the most awkward point of contact between art that traditionally hasn't been seen as art and art as self-expression is folk art. In its

Figure 4.2 Guerilla Girls, *Do Women Have to Be Naked to Get into the Met. Museum?* 1989. Poster, 11" × 28". (Courtesy Guerilla Girls.)

original setting, folk art doesn't typically exploit self-expression; it's anonymous. But people always want to know who the artist is. The first question asked when a folk artist gets discovered is "Who is this person?" After the great explosion in the Reverend Howard Finster's reputation, a piece by him is interesting to galleries to a large degree because it is a piece by the Reverend Howard Finster. Every introduction to Finster's work mentions his garden and his visionary call to art. These biographical details tell us something about the sort of function this art fulfills, but they also tell us something about the person—they create an identity. And this sort of creation is done more self-consciously for "outsider" art than for "mainstream" art. For reviews of shows by folk artists, a mini-narrative biography is written (with a premium on eccentric details), in a manner different from that employed for a new "high" artist. The principle seems to be that the more "mainstream" an artist is (typically, the more white and male), the less surrounding context is given. How many audiences know the biographical origins and current context for work by Brice Marden?

This emphasis on self-expression has consequences for how we imagine artist–audience relations. In all versions of art in which the idea of self-expression dominates, the idea of audience has a problematic status. References to audience most often relegate it to the role of antagonist, either to the artist's wishes (Serra's *Tilted Arc,* for example) or to "true" art.

THREE TYPES OF AUDIENCE

Through its stories, the art community has implicitly identified a wide variety of audiences: the beloved popular audience (defined religiously, ethnically, socioeconomically), the philistine audience, the professional audience, the frigid middle-class audience, the noble-savage audience, the wealthy audience, the dilettante audience, the audience of one's peers, the speculative audience (of the type that gathered at the auction of Andy Warhol's cookie jar collection). This list is neither complete nor systematic; whether they appear in art journals or at art openings, these stories of art audiences are ad hoc, mentioned with specific incidents and artists in mind, and they really function as myths—more useful than real. As fits their role in art world gossip, most of these audience descriptions are derogatory, and none mesh perfectly with the differing social roles of artists. What is most striking is that while these audience categories are useful for gossip, they are not the ones that artists *use* to create their work (although they may fit into the categories that follow, particularly the third).

The audiences that artists use to create their work are less specific and more value-free, and all are more capable of interacting with the social roles delineated in Chapter 3. According to implicit folk categories set up by the contemporary art

community, there are three dominant versions of what an artist's audience might be: the specific audience, the personal audience, and the incidental audience. Labeling them *folk* categories is important. These categories do not point to objective audiences that exist in the real world, but they are functional. Like other folk concepts, such as the concept of entropy (the Newtonian idea that all things tend to decay or lose energy), they may not be exactly correct in all instances, but they work for most ordinary behavior.

The Specific Audience

This audience is defined not so much by the individuals who make it up as by artists, and how artists think about them. The specific audience is an audience whose carefully delineated parameters ideally situate it to receive a specific work of art. When Robert Rauschenberg puts his signature on a luxury automobile, he knows it will appeal to wealthy, car-loving art collectors who have their cars hand-washed. Such specific audiences imply a model of cooperation between artist and audience, cooperation that results from a set of shared beliefs. The sharing is typically seen as moving in a single direction. In this case, the artist identifies a demand, and gives the audience what it wants. The specific audience, whether created by the entrepreneur or conceived by the social critic, is most typically seen as being articulated for the purpose of marketing one's work. To most artists it is the least attractive of the three audiences.

The dominant mode of audience–artist cooperation, expressed by the idea of "selling out," is perceived as a giving in to an audience, and a giving up of honest self-expression. In a tacit association that probably depends on the myth of the artist as social outcast, self-expression gets linked with wildness and danger; the work of the artist who sells out becomes less dangerous, domesticated. According to the current mythology of how art functions, it is the sellers-out who have the shrewdest idea of their audience, and this has contributed to other artists' instinctual distaste for addressing their work to a specific audience. Further, descriptions of the artist who sells out typically cite the artist as entrepreneur or artist as skilled worker as the dominant social role, and cast them as anything but heroic—the one is seen as lacking morals, the other as lacking personality.

While the specific audience is typically loaded with negative connotations, they are not inherent to the model. The skilled worker, the entrepreneur, the social critic—all these are valid modes of artistic expression, and they do not necessarily imply sacrificing one's principles in their addressing of a specific audience. After all, the artist working for a specific audience may not completely ally himself with that audience. Rembrandt did not please his audience—but he certainly knew it. Contrary to twentieth-century prejudices in favor of the artist as social outcast, an artist's identification with an audience is not inherently bad. It is not necessarily illegitimate or weak-minded for an artist to identify with an audience.

The Personal Audience

This form of audience is the opposite of the specific audience. The personal audience derives from the claim that an artist makes art for himself, as Georg Baselitz asserts in the epigraph to Chapter 3. While that declaration of independence might seem to arise from such myths as the artist as genius or the artist as social parasite, such a solipsistic version of audience doesn't work with even these ideas of the *social* role of artists. The artist as genius exists because his genius is recognized by an audience, even if that recognition occurs after the artist has died a miserable death in some unheated, rat-infested garret. Even the artist as social parasite exists because she has a society to burrow into and feed off. Baselitz's assertion that he makes art for himself pushes his audience into a certain kind of appreciation, one that admires the solitary genius, one that looks to his art for self-expression, or some kind of antagonism (however oblique) to contemporary society or art-making.

Furthermore, most artists really *do* care about what happens to their work after they make it. And it's not just Richard Serra launching costly lawsuits to keep his *Tilted Arc* permanently in place, or Mark Rothko buying back his own work because he's horrified about where it has been hung. Chaim Soutine would routinely attempt to buy back his own paintings and, because he considered them defective or because the inferior paint he had used had begun to crack, would burn or slash them, frequently in front of the works' horrified former owners. In France, a well-established body of law is concerned with an artist's moral rights (*droits morals*); much of it deals with the "right of integrity." Artists have the right to prevent others from changing or destroying work without their consent. In the United States, such law is less well established, but artists such as Richard Serra do bring suits attempting to claim rights to their work even after giving up their ownership of it. Thus, not caring about one's audience really is a myth. While the *appearance* of indifference does exist, this appearance is more useful than it is true.

What is useful about this myth of painting for oneself? Both artists and their actual audiences gain from it: Artists gain freedom to work, and freedom from worry about consequences. The audience for the kind of art produced by this attitude enjoys being nudged into the role of voyeur—looking in, uninvited, at supposedly private acts ranging from displays of genius to shocking self-revelations. The general public also uses this myth of painting for oneself but at times uses it to marginalize art. If art is not concerned with communicating with them, why should they look at it, let alone *fund* it?

If an artist really believes she makes art just for herself, *any* kind of interaction with a larger artistic community is not useful, or exists only to affirm what she is doing (and such affirmation should be inherently uninteresting or even dangerous to her and her art). Any attempt to address an external audience gets the same form of stigma as is typically attached to the specific audience. Further, communication becomes extremely difficult under such terms. But this lack of communication is

also useful: because it closes off communication, such a version of audience also closes off evaluation.

Thus, while suggesting radical honesty, the idea of art for the artist alone can be a defensive posture. This idea is commonly invoked by students—artists who aren't in a position of power, whose work is always in a context of evaluation. Those artists with more cultural power, exhibiting with confidence and profit in commercial galleries, invoke it as a gesture of freedom (and perhaps of shrewd marketing) to the viewer: "You can interpret this any way *you* want to." For all their apparent honesty and modesty, such statements, while not necessarily defensive, close off communication between artists and an audience.

The Incidental Audience

This view of audience negotiates a position between the two extremes of the specific and the personal, and is probably the most common. Many artists work with the idea of their audience being split in two. First, these artists paint primarily for themselves. But this statement does not necessarily suggest an untrammeled self-expression, although it may. More likely, it suggests a tendency to privilege self-exploration, process over finished product. It suggests freedom from constraints of subject matter, technique, external criticism, and finances. It also suggests honesty.

However, the artist is only half the audience, useful for a variety of reasons but incomplete. In the course of an interview, David Wojnarowicz articulates in a standard, almost offhand manner, what the second half might be:

> [A]fter the initial wave of acceptance, culminating in the Whitney Biennial, came the tail end of the cycle when suddenly, for a period of time, nobody was interested in what I was doing. That was also educational. I had to decide what I most cared about in my life, what was most important to me. To me it was making things, and although I'll make work that operates as communication for others to see, I also make it for myself.[11]

Along with the personal audience, then, there is what might be termed an "incidental" audience—an audience that Wojnarowicz here embeds, almost as an afterthought, in his last sentence. This incidental audience is a usefully vague group for many artists. It may consist of critics. Or one's peers, who are interested in the work out of friendship, out of professionalism, or (best yet) out of jealousy. Or members of a community that shares some common beliefs. Or a buying public. Or the odd amalgam that shows up on opening night. They get attracted to a work for any number of reasons, such as wanting to affirm the artist's stature as a real artist, wishing to be shocked, curiosity, fashion, and a desire to see compelling art. This audience is useful in its vagueness because it gives artists a lot of freedom to make what they want.

This downplaying of the actual composition and interests of the incidental audience has consequences for how art is seen and talked about. Specifically formed audiences tend to have an explicit ideological interest in the artworks, as did, for example, José Clemente Orozco's audience of poor urban Mexicans. By contrast, a vaguely constructed audience encourages an artwork's formal properties to be its most important aspect, for formal qualities give the *appearance* of being addressed to a more universal audience than ideological assertions do. Of course (as is shown in the discussion of the 1984 MoMA primitivism exhibit later in this chapter), formal properties do contribute to several fairly specific social roles. For example, they often correspond to the idea of the artist as intellectual or genius, removed from daily concerns.

The idea of the incidental audience can imply that an artist is so much a genius that her self-expression is inherently interesting. Further, when the audience really feels itself to be incidental in the presence of such egocentrism and apparent solipsism, it does not always walk away. As a result, the audience can find itself in a voyeuristic position. But the voyeurism may have an odd twist. For such an incidental audience, it is voyeurism made possible by permission from an exhibitionist. How else could one account for Julian Schnabel publishing his memoirs (*C.V.J.: Nicknames of Maître D's and Other Excerpts from Life*) at the age of thirty-six?

As the claim about voyeurism might suggest, the negative consequences of working with the idea of an incidental audience are not usually found in the artwork's characteristics. It's not what a work looks like, it's what people do with it. The possibly negative implications lie in the *relationship* between the artist, the work, and its audience. By adopting the model of the incidental audience, artists can easily ignore the possible results and future functions of their work. They can also deny responsibility for it, with such claims as "Art is responsible only to itself."

This is not to suggest that artists should give up the idea of the incidental audience—it gives space to experiment, particularly at a time when one's work is changing. Further, as Chapter 2 suggests, an artist can't articulate her foundational beliefs every time she paints. But the idea of the incidental audience does not get rid of the problem of audience in the construction of art. It just makes it more diffuse, more open-ended, less predictable.

This diffusely defined, incidental audience shows that the artwork's meaning is unstable. It is unstable because the artist's understanding of her social role may very well differ from the role that the artist's audience is assuming for the creator of this work. They have different expectations for what the artwork is doing, and different evaluative criteria. The artwork's meaning is also unstable because the nature and function of its audience change. Just as there are different social roles for artists, there are different kinds of audiences, varying by size, age, gender, function, and so on. These audiences do different things when they look at art: they are polymorphic, shifting gradually in functions, forming temporary allegiances, even changing as their moods change. No wonder artists have constructed the myth of the fickle

audience. This evanescence results in an unstable relationship between audience and artwork, and one that the interaction between an artist and audience can do little to stabilize.

The possible relations between artist, artwork, and any of these three audiences—specific, personal, and incidental—constitute the work's social function. Part of this function is determined by the artist's social role. The function is further shaped by the current physical environment of the artwork. But the social function of art is also shaped by its audience, what an audience does, and everything that members of an audience bring to their experience of an artwork, including their beliefs about art and the world, their knowledge (true or mistaken) about the artwork and the artist. And the function is informed by the psycho-bio-social identity of the audience. It *does* matter whether the audience is gay or straight, male or female, or Presbyterian or Buddhist.

The social function of an audience has taken on a particular function in contemporary art. Perhaps more than in earlier times, artists now are concerned with how audiences *complete* their artworks' meaning. For example, in Ann Hamilton's 1988–89 installation at the Museum of Contemporary Art in Los Angeles, *the capacity of absorption,* the viewer entered a room whose walls were covered with wax-coated paper, from which protruded copper pipes supporting a glass of water (Figure 4.3). Small whirlpools spun and hummed in each glass. If viewers spoke near or into a mouthpiece suspended from a large flax-wrapped apparatus (modelled on a seventeenth century megaphone), the whirlpools would respond to the voice level. As long as people spoke, the water would quiet; as soon as they were silent, the whirlpools resumed. Without its audience, this artwork in a sense does not exist.

This function of an audience can be carried out by either specific or incidental audiences. For example, in the late fifties and early sixties, Fluxus artist George Brecht would send small cards to a very specific audience: his friends. On the cards were simple sets of instructions to be carried out, often privately, by the recipient. But Brecht did not call these interactions "artworks"; he called them "events." The terminology is essential, for the artwork did not exist until the interaction had taken place. More typically, audiences are less clearly defined and less specific, for they complete the meanings of artworks in a more public context, such as a gallery, a storefront, or a city street. The makeup of this audience can be only partially controlled, if at all, although the creators of such works usually have very specific ideas for *how* this interaction is to take place. Hamilton's *capacity of absorption* is a case in point.

Complete control of the audience is impossible, because even the most narrowly defined art does not have a homogeneous audience. Brecht's work is a useful example: While Brecht could control the makeup of his initial audience (although he couldn't control their responses), his work also has a larger audience, the hugely diverse group of people who either saw the final pieces or heard descriptions of the

Figure 4.3 Ann Hamilton, *the capacity of absorption,* 1988. Installation. Beeswax, glasses with spinning vortexes of water, flax megaphone, video. (Sean Kelly, New York; photo Wayne McCall)

process of these works, and for whom this work exists as conceptual art. Audiences for art are usually less stable than those for Brecht's events, and artworks sometimes are peculiarly energized by this instability. The Reverend Howard Finster claims the function of his work is to preach to an audience of unconverted people who will learn from his messages, but judging from critical response to Finster's work, that specifically functioning audience isn't doing what he wants it to when it turns up at his shows or when it buys his work. In the early 1990s the African-American artist Carrie Mae Weems was part of a group exhibition that traveled to Dalhousie University in Halifax, Nova Scotia. Weems's work superimposed written racist jokes onto photographs depicting racial stereotypes. Knowing the controversy surrounding Weems's work, the gallery attempted to control response by giving as complete a context to the work as possible, including an interview with Weems in which she clearly stated her aims for the show. But a large portion of the local African-Canadian community not only found her use of stereotypes offensive to them, but wondered how white audiences might use her work to reinforce racial stereotypes. The show stayed, but barely.

As the example of Weems shows, artists and their galleries do try to control their audience. They do so by publishing statements with the showing of their work; they control gallery lighting and access; they shape their work's publicity. Some installation artists are extreme in their exercise of control. Robert Irwin opposes photography of his installations (believing that photography cannot capture the subtle illusions of space), and James Turrell limits visitors to his *Roden Crater Project* to a maximum of four people at a time, for a minimum twenty-four-hour visit.[12] But such attempts at control are doomed to failure. While the current make-up and function of her audience are not completely arbitrary, could Frida Kahlo have predicted that her reputation would skyrocket in the late twentieth century, that her work would appear in a department store window display and would be collected by someone like Madonna? Could Robert Mapplethorpe have predicted that Senator Jesse Helms would be his most tenacious audience?

SOCIAL FUNCTION AND AUDIENCE

Audiences, entities whose actions are perhaps best defined in terms of their social function, interact in some standard ways with artworks and artists in this century. Through a few narratives, this section will explore two dominant forms of interaction to show how audiences shape and clarify an artwork's function. The first part of this section examines what happens when an artwork is introduced into a new context, when the physical art object doesn't change but its audience (and consequent function) does. The second part examines conflict between artist and audience, conflict that arises because audience and artist have different expectations for art's social function, for its context.

Changes in Function

In 1984 the Museum of Modern Art in New York put on an exhibition titled "'Primitivism' in 20th-Century Art: Affinity of the Tribal and the Modern," presenting about 150 works by Western twentieth-century artists such as Gauguin, Ernst, Klee, Miró, and Picasso, juxtaposed to about 200 tribal works from North America, Africa, and Oceania. The show's strategy was to see these pairings in Western terms; as MoMA director William Rubin was to point out in his lengthy introduction to the catalogue, the show's "primary purpose [was] the further illumination of modern art." The comparison depended on shared characteristics, and for the MoMA directors, the most reliably shared characteristics were formal ones. As codirector Kirk Varnedoe was to assert in his preface, "We should recall that modernist primitivism ultimately depends on the autonomous force of objects—and especially on the capacity of tribal art to transcend the intentions and conditions that first shaped it." And from this pairing might even come an understanding of primitive art. Rubin stated as a secondary goal that these modernist-inspired comparisons "may nevertheless shed some new light even on the Primitive objects." Making claims for "all great art," Rubin argued: "If the otherness of the tribal images can broaden our humanity, it is because we have learned to recognize the otherness in ourselves."[13]

Easily the most controversial major show of the 1980s (and perhaps the several decades before and the decade since), it ignited multi-voiced responses in many of the major art journals. The controversy surrounding the show is most clearly demonstrated by the word *affinity*: the word implies not just the influence of one culture on another, but kindred pairings of concern between Western art and tribal art from a variety of cultures. Thus works could have an affinity with each other even if it was clear there was no way one could have *influenced* the other. The tribal work became the crux for reaction. In discussions of this show, three relevant contexts for the tribal work were delineated: the original tribal context, with its ritualistic function; the context in which these works were placed when they had their most relevant affinity (such as Picasso's buying a Grebo mask and hanging it in his studio), with its function in the creation of modernism and the avant-garde; and the 1984 context, these two groups of works hanging together in MoMA in a New York City museum, functioning as a formalist interpretation of art history.

The negative reviews were fierce, and all implied that the consequences of this show were large, ranging beyond the formal premises on which the show was based. The critic Thomas McEvilley opened the argument in *Artforum* with the charge that MoMA intended to keep viewers' responses to the show "closely controlled, both by the book and, in the show itself, by the wall plaques."[14] This control was not innocent, McEvilley asserted. James Clifford was to second this view a few months later in the pages of *Art in America*: The tribal works were presented in a deviously incomplete context, he wrote. According to Clifford, they were presented just for their formal properties (defined by Western standards): "At MoMA

treating tribal objects as art means excluding the original cultural context. . . . Indeed, an ignorance of cultural context seems almost a precondition for artistic appreciation." These formalist criteria, feigning neutrality, in fact impose on the tribal works a new function. The big argument here is about the *function* of the work; the objection is that the curators were *changing* the audience. Looking at objects set against a white gallery wall pushes the viewer into an activity very different from participating in a ritualistic dance. As Clifford grumpily put it: "A three-dimensional Eskimo mask with twelve arms and a number of holes hangs beside a canvas on which Joan Miró has painted colored shapes. The people in New York look at the two objects and see that they are alike"[15] (Figures 4.4 and 4.5).

In encouraging these kinds of activities, MoMA was asserting a further principle: These tribal and Western works are not radically different from each other. According to Clifford, there is a "common quality or essence joining the tribal to the modern." The great unstated project of the show, then, is imperialist:

> The affinities shown at MoMA are all on modernist terms. The great modernist "pioneers" (and their museum) are shown promoting formerly despised tribal "fetishes" or mere ethnographic "specimens" to the status of high art and in the process discovering new dimensions of their ("pure") creative potential. The capacity of art to transcend its cultural and historical context is asserted repeatedly.[16]

McEvilley similarly claimed that MoMA was "co-opting" the Third World.[17]

The directors of the show concurred that they had not presented a complete context for the tribal works. Writing in response to his critics, Kirk Varnedoe argued that the first purpose of the show was to look at issues "raised by the forms of the objects, rather than with the other kinds of questions that could only be answered by supporting texts about their origins or functions." Characterizing his opponents as claiming that "you really can't know any one thing unless you know everything," Varnedoe went on to state that knowing the entire context wasn't necessary; in fact, such "selective matching" permitted useful forms of knowledge to surface. The incompleteness allowed for communication between cultures, and in a way that repeated in some form the context of early modernism. Picasso couldn't possibly have known much about the original functions of these pieces, and so he set this knowledge aside. Picasso engaged in "an aggressive recontextualization of tribal objects, out of the (by now largely discredited) web of contextual 'knowledge' that had held them distant and in significant senses invisible, into the volatile taxonomic category of art, then in upheaval." According to Varnedoe, Picasso's doing so, and MoMA's repetition of that act, asserts that there is useful sameness between cultures, and that to argue against such an assertion results in a lack of communication: "If there's really *no* commensurability between epistemes, and no way to know the Other in our own language, then that is that, and we close the book and hunker down at home."[18]

Figure 4.4 Traditional mask. Nunivak Island, Alaska, early twentieth century. Painted wood and feathers, 12 5/8" high. (Courtesy of the Thomas Burke Memorial Washington State Museum, catalog #2-2128.)

Figure 4.5 Joan Miró, *Carnival of Harlequin*, 1924–25. Oil on canvas, 26" × 36 5/8".
(© 1997 Artists Rights Society (ARS), New York/ADAGP, Paris. Photo courtesy of Albright-Knox Art Gallery, Buffalo, New York. Room of Contemporary Art Fund, 1940.)

But illuminating the political dangers inherent in changes in social function does not solve the problems inherent in such changes. Were critics of MoMA, then, asserting that different cultures can't talk to one another? Or that it is wrong at times to use one's own terms in communication? Is re-creating an earlier, somewhat imperialist appropriation of another culture automatically a bad thing?

It's hard to be consistent in answering these questions. Even the most single-voiced answers float around in funny ways. Consider the discipline of art history, where these questions are addressed most systematically. Art historians frequently try to re-create the original audience: What would that audience have seen, done, noticed? But, as the critic Tamar Garb does in writing about Renoir, historians at times claim we ought to be a *better* audience than the original audience, that we should see things that the original audience was too deeply implicated in to be able to see. Garb begins her article on a Renoir exhibition with the following assertion: "One would have hoped that the recent Renoir exhibition would have provided an opportunity for a reassessment of the artist in terms which distance themselves from the nineteenth-century categories through which he has been traditionally viewed."[19] This sort of statement is central to contemporary experiences of art. For example, in a postcolonial world many late-twentieth-century viewers *do* see things about the work of Ingres that his original audience did not see (for example, his Orientalism and the presuppositions behind that), and furthermore, few these days would argue that viewers should give up this knowledge.

What allows Garb to claim this for Renoir's modern audience, while the curators of MoMA's primitivism show would never have claimed that they, or the moderns, were a better audience than the original tribal audience? What makes one instance of changing a context unremarkable, and another suspect? While the temptation may be to evoke models based on awareness of power and imperialism, such models reduce all such changes to politics. A more useful model might be kinship. Members of the same family can engage in the most horrific fights, but they often will unite to turn on someone from outside the family who is foolish enough to attack someone within the family.

Members of the art community feel that although they can change and critique contexts of which they are securely a part, such change and critique becomes dicey when applied to contexts and cultures of which they are not a part. For the purposes of her essay, Garb can recontextualize Renoir because she and Renoir are part of the Western-high-art family, and she is also a part of the family being depicted (women); MoMA curators were attacked because they were not part of the tribal family whose art they recontextualized. The principle is this: When audiences do move in to criticize, they first declare their sameness, either with the object depicted or with the artist. Some artists and audiences claim familial connection (based on a specific gender, sexual orientation, or ethnicity); others claim membership in a large general family (the human race). Such kinship claims are omnipresent, and are not without their political consequences. Consider, for example, what can happen when one silently removes cultural specifics, such as gender and race, from discussions of art.

In his conservative critique of American education, *The Closing of the American Mind,* Allan Bloom claims to be a member of a general human race, which for him is the only relevant family when it comes to artistic expression (of course, Bloom also implicitly defines himself as the father).

Changes in an audience's function are not limited to the sorts of reactions provoked by the MoMA show. Another aspect of change in function is shown by the shifting reputations of artists, something that is much more interesting and complicated than mere shifts in "taste." Why are some things more popular at some times than at others? Embedded in this question is the question of permanent standards, which is answered with what might seem a relativist challenge: How can there be absolute standards of *artistic quality* if the functions of art change?

For example, consider the work of Frida Kahlo. While she was alive, Kahlo was known as the talented wife of Marxist muralist Diego Rivera. Kahlo's work is quite different from his. Her medium was canvas and, while her paintings included historical references, they were radically autobiographical, both in their imagery and in that they featured the distinctive face and body of Kahlo herself (Figure 4.6). As Kahlo was to comment, "I paint myself because I am so often alone, because I am the subject I know best."[20]

By the early 1990s, Diego Rivera had become known as the talented husband of Frida Kahlo. Kahlo's work has become the focus of enormous interest and the inevitable financial speculation. As one critic reports, prices have climbed from $19,000 paid for a painting in 1977 to more than $3 million for a self-portrait in 1993.[21] Kahlo's reputation has risen to such heights that many unguardedly call it a cult: A 1991 article in the *Oxford Art Journal* has as its subtitle "De-frocking the Kahlo Cult," and the April 1994 issue of *ARTnews* titles its cover story "The Kahlo Cult." These articles cite as their evidence Kahlo's audience: Kahlo is the subject of a feature-length movie and an opera, she is the subject of articles in *Elle* and *Vogue,* she is the theme of a café in West Hollywood, and she is collected by Madonna. The latter's image has appeared with Kahlo's in an elaborate department store window display, and Madonna has hung Kahlo's *My Birth* in the entrance to her home.

What change has made Kahlo a major figure? The audience for Kahlo's work today is new (in both its members and its function); the audience for her work has shifted. It is an audience that considers biography and gender identity to be important in assessing art. As her biographer (herself a major cause for Kahlo's new prominence) writes, "A Hispanic woman, bisexual, an invalid and an artist—all the qualifications for a cult figure."[22]

The flip side of this change in reputation, but subject to the same principles, is the work of Auguste Renoir (Figure 4.7). Early in this century, Renoir was seen as one of the great forerunners of modernism, as one of the heroic leaders of a revolution in painting, radically shifting the approach to surface and light. But by the mid-1980s, something in Renoir's audience had changed. The big traveling retrospective of 1985, unlike the earlier major Monet show, pretty well killed his reputation among his elite and professional audience.

Figure 4.6 Frida Kahlo, *Diego and I,* 1949. Oil on masonite. 11" × 8½".
(Courtesy Mary-Anne Martin/Fine Art, New York.)

Figure 4.7 Pierre-Auguste Renoir, *Girls Picking Flowers in the Meadow,* 1890.
Oil on canvas, 65 × 81 cm. (Juliana Cheney Edwards Collection. Courtesy Museum of
Fine Arts, Boston.)

A symposium about the show, featured in *Art in America* in March 1986, reads like an art history version of showoff playground basketball. Peter Schjeldahl claims, "Renoir may be the worst artist to achieve canonical status, but this pales, for me, beside the complexity and poignance of his very badness. . . . How bad was he? Let me count the ways." Walter Robinson, clearly enjoying himself, writes, "Poor Renoir. There he was, leading painter of the good life in 'modern' Paris, a veritable Pollyanna with a paintbrush, recording classic scenes of idle delight with unrelenting good cheer and a shimmering dapple of rainbow-bright hues. And then look at what happens. His subjects all turn to 'kitsch.'" Such damnation made Renoir's current supporters nervous and muted in comparison to earlier proclaimers of his greatness. From his adherents, Renoir received cautious praise. One of the more *positive* responses, from Robert Rosenblum, was couched in the following way: "Future studies of Renoir will have to remove him from the history of Impressionism and relocate him somewhere to the left of Bouguereau."

What are the reasons for this drastic change in evaluation? Some of the rereadings are based on formal principles: Peter Schjeldahl complains that Renoir's colors are "tonally chaotic," and Michael Fried decries his lack of touch. But these are not just formally based criticisms, for they are tied to the idea that Renoir wasn't really an innovator. As Carter Ratcliff writes, Renoir was "not a radical artist, but [he is] important because he shows how easy it is to look like one, to be scorned and then revered as an 'intransigent,' while preserving the authority of standard forms and taste."[23] And this awareness of Renoir's shallowness gets to be part of political evaluations of Renoir, particularly of his relation to bourgeois culture and feminism: "His sunny scenes are prophetic of the modern postcard, his sensibility is common ancestor to Norman Rockwell, Barbie and slice-of-life advertising," Walter Robinson wrote. "Renoir's painting may be trivial and obvious, but at least it's definitive." Lynda Nead would go further, and implicate art criticism in contemporary culture's adoption of Renoir's nudes as a sexual philosophy.[24] Clearly, the critical members of Renoir's current audience overlap with Kahlo's (for example, in their interest in how gender is represented), and demonstrate the same principle: Changes in reputations are based on seeing new things, on evolving belief systems and functions.

Conflicting Expectations for Function

The changing of function for artworks has occurred throughout art history in the West, but in this century it is probably not the most spectacular mode of artists' and audience's interactions with artworks. That honor may well belong to *conflict* between an artist (or artwork) and an audience, conflict arising because of incongruent expectations for art's social function. Conflict is a form of interaction that has dominated twentieth-century art. The audience's role in this conflict is more important than its makeup, although its makeup obviously shapes its role. This sec-

tion will explore conflict in two directions: the influence of conflict in shaping the context of contemporary art, and the influence of conflict on public art. The first topic is discussed through the history of a famous exhibition.

The exhibition has come to be called the Armory Show, named for where it was held in New York early in the spring of 1913: the 69th Regiment Armory on Lexington Avenue.[25] It was organized by the Association of American Painters and Sculptors, a new group that had formed in opposition to what it perceived as the stifling, conservative influence of the National Academy of Design. After closing in New York, the show moved in a smaller version to Chicago for a month, and then on to Boston. Although attendance in Boston was disappointing, the show was a huge success in New York and Chicago, attracting 87,000 in New York (between 10,000 and 20,000 each day on the last few days of the show), and about 200,000 in Chicago, where news of the show's scandalous nature had arrived before the show did. It was a large show, containing about 1,300 works, of which about 800 were American and 500 European. The American artists included Mary Cassatt, Stuart Davis, and Marsden Hartley. With the exception of the futurists, the major representatives of the European avant-garde were included, among them Marcel Duchamp, Pablo Picasso, and Constantin Brancusi. Earlier painters, such as Paul Cézanne, Paul Gauguin, and Vincent Van Gogh, still new to most American audiences, were also represented.

Those three precursors of France-based modernism suggest the show's specific purpose: to change the context for contemporary art, and through that to change the face of American art. While the show was being assembled, Walt Kuhn, one of its organizers, wrote to a fellow organizer: "We want this old show of ours to mark the starting point of the new spirit in art, at least as far as America is concerned" (Brown, 56). Mabel Dodge Luhan, an art patron associated both with the literary avant-garde and the show, wrote to Gertrude Stein (often promoted at this time as a "literary cubist"): "This will be a *scream!* 2000 exhibits in the great armory of the 69th regiment! The academy are frantic. Most of them are left out of it. . . . I am *all* for it. . . . There will be a riot & a revolution & things will never be quite the same afterwards."[26] The preface to the catalogue for the show, written by a member of the organizing committee, was a little more circumspect, but reveals the same concern for shaping the context in which the show would be received: "This is not an institution but an association. It is composed of persons of varying tastes and predilections, who are agreed on one thing, that the time has arrived for giving the public here the opportunity to see for themselves the results of new influences at work in other countries in an art way" (*1913,* 157). While the show was much more polemical than this statement might suggest, the quotation does quietly present the intended function and context for the show: educational and transformative.

The organizers of the show educated its audience not just through the selection of artists, but through a rigorously organized publicity campaign, involving press releases, pamphlets, selected biographical information, and tantalizing

secrecy. The publicity was an attempt to *manage* the show's context, a form of management that is common to all artists. And the publicity created the terms of the conflict that resulted from the show. For the organizers of the Armory Show, publicity was essential to achieving its purposes. As Kuhn argued in the letter quoted previously, "I have planned a press campaign from now right through the show and then some. . . . John Quinn, our lawyer and biggest booster, is strong for plenty of publicity. He says the New Yorkers are worse than rubes, and must be told."

What sort of people made up the Armory Show's audience? Other than the fact that almost everyone who saw the show was aware of its publicity, the one generalization that can be made is that it was not an audience for whom the European works were familiar. The last contact with European art most Americans (including critics) had had was with impressionism. For most, the Armory Show was the first time they had seen even Cézanne. By the works they included, the organizers clearly proposed a change in what these people considered contemporary art, and the nature and characteristics of this change were at the center of discussion and conflict.

This uninformed audience for the Armory Show is also usually depicted as intensely involved with the work. Probably the wealthiest woman in America, Mrs. John Jacob Astor, appeared at the show each morning after breakfast. A member of the Morgan family, a rival of the Astors in wealth, complained about the 25-cent admission fee to see such awful painting. And one of the most famous people in America, superstar tenor Enrico Caruso, "turned up one Saturday afternoon and thrilled the crowds by doing caricatures of the paintings on Armory Show post cards and distributing them as souvenirs" (Brown, 116–17). The reactions of the general public were frequently a mixture of outrage and comedy. According to one of the running gags about the Armory Show, "It is a long step from Ingres to Matisse, but it is only a short one from Matisse to anger" (Brown, 112). As William Zorach, a contributor to the show, remembered it, "The crowds piled in and out day after day—some hilarious—some furious—none indifferent. There was never anything like it—so completely a surprise—so completely devastating to the complaisant American" (*1913*, 94).

Laughter and anger quickly became the dominant modes of characterizing audience reaction in the popular press. *The Chicago Record-Herald* announced the arrival of the show in Chicago with the following headline: "Cubist Art Is Here: As Clear As Mud." The New York *Sunday World* asked the question "Did the Armory Show puzzle you?" and offered a prize to anyone who could "translate" Picabia's publicity statement on contemporary art. The prize was an "original" cubist drawing by one of the *Sunday World*'s staff (*1913*, 161–62). The *American Art News* offered ten dollars to the person who could best find the nude in Duchamp's *Nude Descending a Staircase* (Brown, 110). Duchamp's painting rapidly evolved into the cause célèbre of the show. The newspapers competed to come up with the wittiest description: an "elevated railroad stairway in ruins after an earthquake," a "dynamited suit of Japanese armor," an "academic painting of an artichoke," and, most popular, "an explosion in a shingle factory" (Brown, 110) (Figure 4.8).

THE EVENING SUN, THURSDAY, MARCH 20, 1913.

SEEING NEW YORK WITH A CUBIST

The Rude Descending a Staircase
(Rush Hour at the Subway)

Figure 4.8 J. F. Griswold, caricature of Marcel Duchamp's *Nude Descending a Staircase,* published in the (New York) *Evening Sun,* March 20, 1913.

The recurring reaction to the work of Henri Matisse was venomous rather than humorous. Most famous was Matisse's reception in Chicago, where students at the Art Institute planned to hang in effigy Matisse and two others. After the administration made some discouraging noises, the students instead created a fictional character, Henri Hairmatress, "who was accused and convicted of a long list of crimes, then stabbed, pummeled, and dragged about the terrace [of the art museum] to the edification of a large crowd on Michigan Avenue. Imitations of Matisse's *Luxury* and *The Blue Lady* were burned . . ." (Brown, 178–79).

Is the only thing one can learn here about audiences that they provide a possibly volatile context? Did such a circus produce any useful forms of knowledge and action? It did, in two forms. First, nearly all responses to the Armory Show, positive and negative, did something that all audiences tend to do when experiencing new work: they tried to produce a tradition to which these works belonged, or, to these works' discredit, did not belong, hunting categories out of the past that either exonerate or castigate the new, or gathering a tradition out of the new, finding a way to put all the new works together or a way to make fine distinctions among them.

Those who rejected the principles of the Armory Show did something like that. Some suggested that the show belonged to a tradition of American showmanship and charlatanism, as did Theodore Roosevelt when he asserted that cubist painting was the same kind of hoax as P. T. Barnum's faked mermaid (*1913*, 160). Others presented a more fully thought out argument to place this art in a tradition. Kenyon Cox, author of one of the three most influential negative reviews of the show, did not argue that Matisse presented a great rupture with artistic tradition. In fact, he placed Matisse and others solidly in a tradition:

> I wish I could feel, as they [other critics] do, that there is a sudden dislocation with the appearance of Matisse and that everything before him falls naturally into its place as a continuation of the great tradition. I wish I were not forced to see that the easy slope to Avernus [hell] began as far back as the sixties of the last century.

Cox then went on to cite a tradition of art that relies on an essentializing definition of the sort discussed in Chapter 1. Art is one thing, and one thing only:

> The real meaning of this Cubist movement is nothing else than the total destruction of the art of painting—that art of which the dictionary definition is "the art of representing, by means of figures and colors applied on a surface, objects presented to the eye or to the imagination." (*1913*, 65–66)

For those whose opinion of the Armory Show tended to swing in the opposite direction, constructing a tradition, a context, still remained the central critical enterprise. In a letter to the editor of the New York *Evening Post,* Joel Spingarn, professor of philosophy at Columbia University, tied these painters to the tradition of self-expression in art: "Wrong-headed, mistaken, capricious, they may all turn out to be

for all I care; but at least they have the *sine qua non* of art, the courage to express themselves without equivocating with their souls" (Brown, 156). As it was for Cox's, an essentializing definition of art was useful to Spingarn's argument. This emphasis on a single definition of art as self-expression was echoed by an editorial in the Chicago *Evening Post,* which claimed of the show: "And however incomprehensible its methods may be, it at least embodies a spirit of individualistic revolt that ever wins the respect of men" (Brown, 180). Walter Pach, in a piece published in a publicity anthology titled *For and Against,* while arguing that the work of the Cubists was "a radical departure from preceding forms," claimed that it nevertheless created a tradition for these artists. For Pach, the tradition was to be found in another art, music:

> [T]he men badly named "Cubists," have followed an exactly similar direction to that which was found in the art of music, and as, in the latter art, the possibilities of expression, were infinitely increased with the change from the representation of the actual to the use of the abstract, I think that the men conferring a similar increase in freedom in the graphic arts, would be entitled to our profoundest gratitude. (*1913,* 164)

And Pach could consequently construe the cubist artist as belonging to the great tradition of the twentieth century, the tradition of no tradition, the tradition of the avant-garde: "I should say that those who can learn from the example of the past will judge the works of the present day Frenchmen not by the distance they have traveled from their predecessors, but by what they will mean to the men who will come after them."

As for that future meaning (one of the major effects of the Armory Show), the popular press came up with two seemingly contradictory readings of the show. On the one hand, cannily understanding its readers, it tended to predict that this new art would not last, that it would die under the withering scorn of the great American commonsensical audience. The *American Art News* prophesied that "New York's laugh will bury these new apostles of art in oblivion" (Brown, 139). On the other hand, reviews of the show tended to call it a success. And it was a success for newspapers, for it made headlines and generated a huge readership. That publicity, even negative publicity, also helped give this art a foothold in America.

This foothold indicates the second form of useful knowledge or action that the wild reaction to the Armory Show produced. The show had an enormous effect on contemporary art, artists, and audiences. That it had an effect points to the future, and in this future, contemporary art, artists, and audiences are all forms of audiences of the Armory Show. The people in the Armory Show audience were extremely diverse: press, promoters, critics, celebrities, artists, collectors. All had differing purposes and were changed in different ways.

One way of understanding this change is by looking at the show's commercial aspect. The show sold 174 works for a total of $44,148.75. While that is a remarkable sum considering the negative attention the show received from many critics,

more surprising is *what* works were sold. Of the works sold, 123 were from Europe, and the European part of the show was by far the most radical (Brown, 97). And the artist who was perceived as the most radical of these radicals triumphed. All of Marcel Duchamp's works sold, including *Nude Descending a Staircase,* which went for $324 to a San Francisco collector who had only read about it. Even Matisse managed to sell a drawing, although its price was a paltry $67.50. The highest price for a work, $6,700, was paid by the Metropolitan Museum of Art for Cézanne's *Colline des pauvres,* the first Cézanne purchased by an American museum (*1913,* 37). The Armory Show also saw the beginning of some major American art collections. Lillie Bliss, whose twenty-six Cézannes (purchased later) became the nucleus of the MoMA collection, bought two Redons and eighteen prints (Brown, 98). Other major collections that had the Armory Show as their major impetus include that of John Quinn, now dispersed; the Louise and Walter Arensberg Collection of the Philadelphia Museum of Art (which includes three of the Duchamps exhibited at the Armory Show); the Collection of the Société Anonyme at the Yale University Art Gallery; and much of the Arthur Jerome Eddy Memorial Collection of the Chicago Art Institute (Brown, 211). These collections give us much of the historical context and many of the antecedents of work being produced today.

That the Armory Show changed the face of modern art in America is also confirmed by its restagings: major reconstructions of the show were held in 1944, 1958, and 1963. These restagings illustrate that not only the public and collectors were audiences that were transformed by the show, but the *artist* audience was also remade. Stuart Davis, an exhibitor at the 1913 show, wrote fifty years later: "My personal reaction to the rowdy occasion was an experience of Freedom, no doubt objectively present in the mechanics of many of the foreign items in display." Charles Sheeler, another exhibitor at the Armory, was to recall, "As for me I found much beauty in it and a new way of life" (*1913,* 95). The list of changed artists could be expanded indefinitely: the transforming context that the Armory Show provided affected the work of many artists who were to dominate American painting in the first half of the twentieth century.

The conflicts that were part of the Armory Show had a prophetic manifestation in Illinois. When the show moved to Chicago, an agent for the State of Illinois Senatorial Vice Commission, in response to many complaints, decided to hold a "thorough investigation." His careful inquiry revealed that "every girl in Chicago was gazing at examples of distorted art, and that one of the women in Matisse's *Le Luxe II* (*Luxury*) had four toes" (Brown, 175) (Figure 4.9). After some inconclusive debate in the state legislature, the matter was dropped. Although this investigation here was directed at a private art show, it does reveal the beginnings of the ways *public* art would be discussed in the second half of the century.

The conflict between *public art* and its patron/audience is a second forum for examining the antagonisms between artists and audiences. The stories about public art are legion, but conventional, and often they repeat the events surround-

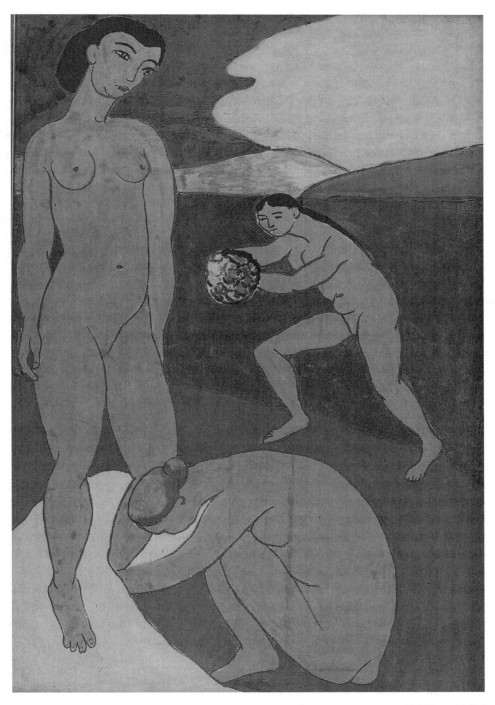

Figure 4.9 Henri Matisse, *Le Luxe II,* 1907–08. Casein on canvas, 82⅛" × 54¾".
(© 1997 Succession H. Matisse, Paris/Artists Rights Society [ARS], New York.)

ing Baccio Bandinelli's *Hercules and Cacus,* located outside the Palazzo Vecchio in Florence. After its unveiling in 1534, "the Florentines stuck nasty sonnets all over it."[27] More recently, in 1967 the city government of Grand Rapids, Michigan, used the first-ever Art in Public Places grant from the National Endowment for the Arts, $45,000, to commission *La Grande Vitesse,* a forty-foot, bright red stabile sculpture by Alexander Calder, and set it up in the new public square (see Figure 1.3). Outrage was swift, directed both at the sculpture and its $128,000 price tag ($83,000 was raised from private donors). But the sculpture stayed. Public sentiment turned, as the sculpture formed the visual center of an arts festival each spring. The Calder triumphed when it became Grand Rapids's logo, appearing not just on the city's street signs but on its garbage trucks.

Many stories don't end that happily; audiences aren't always converted. On October 25, 1993, a solitary structure loomed over the edge of a new park in a working-class neighborhood of London. In its brief existence, it was the focus of a controversy that repeated and exemplified so many of the controversies surrounding art for the past hundred years. In the course of the fight, previous struggles about artworks were often cited, including the works of such artists as the nineteenth-century painter Whistler, the post-impressionist Cézanne, the modernist sculptor Jacob Epstein, and the minimalist sculptor Carl Andre. The thirty-year-old British sculptor Rachel Whiteread had cast the inside of a whole house, filling the interior space with concrete and then removing the walls (Figure 4.10). A block of adjoining Victorian houses had been torn down to develop the park in the decaying East End of London. In the center of the block, Whiteread's sculpture, titled *House,* was all that remained of the homes.

Its admirers saw *House* as a poignant representation of loss. Whiteread herself said that it was a "monument to a house, to a home" that attacked England's "ludicrous policy of knocking down homes like this and building badly designed tower blocks which themselves have to be knocked down after 20 years."[28] Contemplating the unique, personal details evident in its surface (for example, the cast-relief traces of wall sockets, window trim, and doorknobs), some saw an intimate artwork that dealt with memory and transience. One critic wrote that "*House* is about the past and it is also about the unrecoverability of the past, about the fact that what has gone cannot be revived."[29]

But in this negative space made solid, a representation of absence, its detractors saw only an insulting eyesore and a waste of money. Richard Tidiman, editor of the *East London Advertiser,* sniffed: "It is a waste of money, it doesn't do anything and it doesn't look particularly lovely. . . . the £50,000 it cost was never destined to be spent on something 'more worthwhile' for the benefit of East Enders."[30] Tidiman wasn't alone. The former tenant of the house became a folk hero, characterized as "war-hero Sidney Gale," and is quoted as saying "That money would be better spent on buying a new house."[31] Whiteread's stated functions for the work, an elegy to domestic space and an attack on public policy, bumped up against that part of her audience that wanted formal visual pleasure, or, failing that, a spending

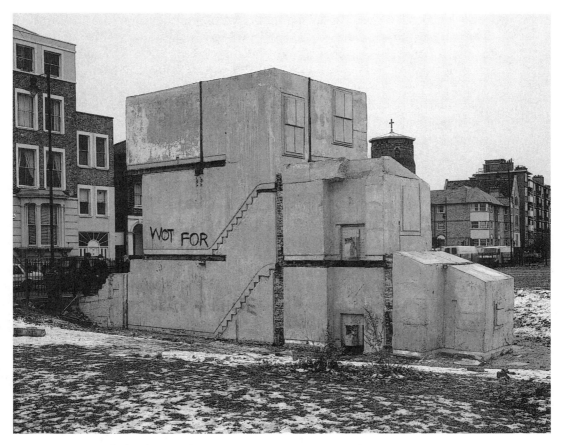

Figure 4.10 Rachel Whiteread, *House,* Oct. '93–Jan. '94. Concrete.
(Commissioned by Artangel. Photo: Edward Woodman.)

of public money on overt social improvement—not on art like *House*. The differing expectations for the function of public art meant that *House's* detractors were unable to interact with the work on Whiteread's terms. On their *own* terms, they were right: as something that was to "look particularly lovely," *House* failed.

In the tradition of ephemeral art, *House* was meant by Whiteread to be temporary, but after the work became public, the enthusiastic sponsors hoped to extend the demolition deadline past the agreed-upon date. Some (in both the neighborhood and the country at large) lobbied strenuously that the artwork be kept permanently. Others wanted it bulldozed, the sooner the better. Things heated up. Less than a month after *House* was complete, Whiteread won the most prestigious art prize in Britain, the Turner Prize. A month and a half later, with bitter and nasty feeling on both sides of the dispute, *House* was demolished.

The interactions between Richard Serra, his *Tilted Arc,* and its audience, which were described in Chapter 1, are even more extreme because of the legal questions, the vociferousness of the debate, and because Serra and the General Services Administration had intended *Tilted Arc* to be permanent. The work wasn't inherently anti-audience: it was conceived of as a site-specific work, with an audience as part of its function. But Serra's audience was interacting with the work of an artist who saw himself as a social critic. The artist as social critic necessarily needs conflict in order for his or her work to complete its meaning (otherwise the artist is simply sculpting to the converted). But the conflicts that arise from *Tilted Arc* and from much public art frequently aren't on the terms the artist sets out—the artist's intentions aren't always realized.

How does conflict typically work in contemporary art? Conflict is not solely destructive, and it follows some conventional patterns. Conflict between artist and audience most typically arises from artist and audience imagining differing functions for art, and differing social roles for artists. Conflict has done much to define art in this century. It has proved itself useful for the marketing of art, it creates traditions, and it sets a context for future art.

Audiences, then, matter to what art means; stories about audiences are not just gossipy additions to an already completed work. Audiences complete an artwork's meaning. The ways that completion happens aren't nearly as stable as many artists might want, despite attempts at controlling those ways. Audiences, after all, like all polymorphic, protean creatures, are very hard to pin down.

NOTES

1. Richard Buckle, *Jacob Epstein, Sculptor* (Cleveland, Ohio: World, 1963), 164.
2. Richard Cork, "Overhead Sculpture for the Underground Railway," in *British Sculpture in the Twentieth Century,* ed. Sandy Nairne and Nicholas Serota (London: Whitechapel Art Gallery, 1981), 98. Evelyn Silber and Terry Friedman, "Epstein in the Public Eye,"

in *Jacob Epstein: Sculpture and Drawings,* ed. Evelyn Silber and Terry Friedman. (W. S. Maney, 1989), 227.

3. Cork, 101. Evelyn Silber, Introduction, *The Sculpture of Epstein* (Lewisburg, Pa.: Bucknell University Press, 1986), 47.

4. Kenneth Clark, "Courbet's Nudes," in *Courbet in Perspective,* ed. Petra Ten-Doesschate Chu (Englewood Cliffs, N.J.: Prentice-Hall, 1977), 56.

5. George Boas, "Courbet and His Critics," in *Courbet in Perspective,* 43.

6. Quoted in Linda Nochlin, "Courbet's *L'origin du monde:* The Origin Without an Original," October 37 (1986), 80.

7. Sarah Faunce and Linda Nochlin, *Courbet Reconsidered* (New York: Brooklyn Museum, 1988), 175–77.

8. See Fernande Olivier, *Picasso and His Friends,* trans. Jane Miller (New York: Appleton-Century, 1965), 68–70; and Roger Shattuck, *The Banquet Years: The Arts in France, 1885–1918,* rev. ed. (New York: Random House, 1968), 66–71.

9. Irit Rogoff, "Production Lines," in *Team Spirit* catalogue (New York: Independent Curators, 1990), 37.

10. Ibid., 78.

11. Barry Blinderman, "The Compression of Time: An Interview with David Wojnarowicz," in *David Wojnarowicz: Tongues of Flame,* ed. Barry Blinderman (Normal: University Galleries of Illinois State University, 1990), 53.

12. Bruce D. Kurtz, *Contemporary Art, 1965–1990* (Englewood Cliffs, N.J.: Prentice-Hall, 1992), 107.

13. *"Primitivism" in 20th-Century Art: Affinity of the Tribal and the Modern,* ed. William Rubin, vol. 1 (New York: Museum of Modern Art, 1984), x, 2, 73.

14. Thomas McEvilley, "Doctor Lawyer Indian Chief: '"Primitivism" in 20th-Century Art' at the Museum of Modern Art in 1984," *Artforum,* November 1984, 57.

15. James Clifford, "Histories of the Tribal and the Modern," *Art in America* 73 (April 1985), 164, 171.

16. Ibid., 165, 166–67.

17. McEvilley, 60.

18. Kirk Varnedoe, "On the Claims and Critics of the Primitivism Show," *Art in America* 73 (May 1985), 11, 12, 19, 15.

19. Tamar Garb, "Renoir and the Natural Woman," *Oxford Art Journal* 8:2 (1985), 3.

20. Quoted in Hayden Herrera, *Frida: A Biography of Frida Kahlo* (New York: Harper & Row, 1993), 74.

21. Judd Tully, "The Kahlo Cult," *Artnews* 93 (April 1994), 130.

22. Quoted in Janis Bergman-Carton, "Like an Artist," *Art in America* 81 (January 1993), 36.

23. "Renoir: A Symposium," *Art in America,* March 1986, 107, 108, 111, 113, 120.

24. Walter Robinson, in "Renoir: A Symposium," 120; Lynda Nead, "'Pleasing, Cheerful and Pretty'? Sexual and Cultural Politics at the Hayward Gallery," *Oxford Art Journal* 8:1 (1985), 72–74.

25. The two major sources of information for the following narrative are the anthology contained in the catalogue for the fiftieth-anniversary reassembly of the Armory Show, *1913 Armory Show: 50th Anniversary Exhibition 1963* (New York: Henry Street Settlement, 1963), and Milton W. Brown, *The Story of the Armory Show* (New York: Joseph H.

Hirshorn Foundation, 1963). All further references to these works will be noted parenthetically. For a more complete record of pamphlets, caricatures, catalogues, and reviews of the Armory show, see *The Armory Show: International Exhibition of Modern Art, 1913,* 3 vols. (New York: Arno Press, 1972).

26. Quoted in James R. Mellow, *Charmed Circle: Gertrude Stein & Company* (New York: Praeger, 1974), 169.

27. Laurel Wood Adams, "Art Press Review," *New Art Examiner,* January 1984, 5.

28. Quoted in John McEwen, "The House That Rachel Built," *Sunday Telegraph,* October 24, 1993. Reprinted in *Rachel Whiteread: House,* ed. James Lingwood (London: Phaidon, 1995), 132.

29. Andrew Graham-Dixon, "This Is the House That Rachel Built," *Independent,* November 2, 1993. Reprinted in *Rachel Whiteread: House,* 134.

30. Richard Tidiman, "When a House Is Not a Home," *East London Advertiser,* October 28, 1993. Reprinted in *Rachel Whiteread: House,* 133.

31. Ulla Kloster, "There's a Stoney House!" *East London Advertiser,* October 28, 1993. Reprinted in *Rachel Whiteread: House,* 133.

Conclusion

The Perfect Picture

Artists reveal something important about their work when they talk about it as "doing art." In his *Art in Action,* the philosopher Nicholas Wolterstorff proposes a functional approach to art: "Works of art are instruments and objects of action—and then, of an enormous diversity of actions."[1] We have also argued that art-making is a social action. Both its social character and its status as an *act* are integral to it. The narratives that open each chapter of this book illustrate the range of those actions: The Reverend Howard Finster's art attempts to convert his audience to a specific religious belief, Robert Morris's art responds to political events, the sculptures of the student at the Glasgow School of Art decorated a shelf, and Jacob Epstein's sculpture offended a board of directors.

The various topics that have revealed *how* art is a social action—belief systems, social roles, audiences—imply the *connectedness* of artworks and artists to other things, and argue that this interconnectedness is essential to understanding art and its conflicts. Chapter 2 shows how artists' belief systems are connected to the multiple sources of those beliefs. The anecdote about Robert Morris that begins Chapter 2 attempts to show that his art is connected to his beliefs, to the world, and to his changing beliefs about the world. But the connection is with something or someone *different* from Morris, and that inevitable difference has great implications for how art communicates, how it might change the world, how it creates and responds to conflict, how it reveals an idiosyncratic creator.

Every artist's belief system is idiosyncratic, but in its idiosyncrasies it is made up of elements that others also hold to and use. Artists' beliefs occur in a conversation with others, and even the conversation that typifies the avant-garde, in its commitment to change and originality, is a shared conversation. Chapter 3, on artists' social roles, asserts a connection between artists and those social roles, those specific actions of and attitudes toward art-making. When Joseph Beuys takes on the role of shaman, he participates in a tradition that he did not originate, and that his audience recognizes and uses to understand his art. Through those sorts of attitudes implicit in all social roles, every artist is connected to specific types of interactions with audiences, which is the topic of Chapter 4. That chapter also asserts a further social connection, in the sense that audiences complete an artwork's meaning.

In asserting that artworks, as social acts, are connected in a web of influence and cross-conversations they cannot escape, this book is extending in a specific direction an insight about the repetitiveness of art that is common to much contemporary critical theory and to postmodernism. For example, feminist theory connects art to traditions of representing the body, and, through work such as Kiki Smith's full-size wax figures which exploit their medium to reveal a painful female vulnerability, shows the power of that tradition. Psychoanalytic theory connects art to powerful urges that have always dominated human activity, depicted in works ranging from Hieronymus Bosch's *Garden of Earthly Delights* to Artemisia Gentileschi's *Susannah and the Elders* to Cindy Sherman's untitled film stills. Postmodern linguistics-based theories, such as that of Jacques Derrida, assert that there is nothing new, that every new artwork is an echo, a leaning back (nostalgic or otherwise) to an irretrievable origin. Marxist theory connects all art to recurring forms of class struggle, whether it be in Sue Coe's Malcom X series or David Hockney's sumptuous images of suburban Los Angeles. This book follows the claim of most forms of these theories that this interconnectedness is not something artists should *want* to escape, since it gives their work its power and communicativeness. As social activity, then, all art is a response to earlier activities. People do not make art by being radically individual, but by using shared codes. And artworks most obviously respond to the codes they share with earlier art, a set of conventions. (By codes and conventions we don't just mean such things as the tradition of the portrait, for example, but also the idea that much painting is presented as a rectangle, a convention to which even a round painting responds.)

Further, an artwork is not complete unless it earns a response from someone else, even if only silence, as the work of Van Gogh perhaps did. The audience completes the utterance, even if by letting the work drop into a void. Ideas about the artist as a completely isolated maker, or as creating pure self-expression, are incomplete. When Georg Baselitz asserts in the epigraph to Chapter 3 that the artist's "social role is asocial; his only responsibility consists in an attitude, an attitude to the work he does," he is declaring the extreme isolation of the artist. Baselitz claims that the artist has "no communication with any public whatsoever. . . . He gives no

help to anyone, and his work cannot be used."[2] He is, in our view, wrong. When Baselitz makes this type of statement he is in fact taking on a social role, one that gets its strength from being communicated to an audience, an audience that associates Baselitz with self-expression, with the (by the end of the twentieth century) tired concept of the artist as mythically isolated hero—to a social role audiences know and use to understand his work.

Misunderstandings about an artist's social role are endemic to contemporary art. In Chapter 1's opening anecdote, the Reverend Howard Finster, telling his story, and Carlo McCormick, reviewing Finster's work for *Artforum,* are connecting their ideas of Finster's work to very different things. The same can be said for the narrative that opens Chapter 3. Students at the Glasgow School of Art were not arguing fruitfully, primarily because they were tacitly presuming different social roles for the artist and applying different functions to the artworks. But misunderstandings also come about through failing to acknowledge the way beliefs surround and are entangled in artworks. So the epigraph to Chapter 1, about the student who "only wants to learn *how* to paint," shows the student's naive attempt to separate painting from philosophy and from beliefs. The student is making a theory–practice dichotomy that is questionable, is ignoring how art interacts with the world, and is withdrawing into a sealed-off place where taking responsibility for art's effects is neglected.

All artworks imply a host of beliefs about art. This seems to conflict with Raphael's comment to Leonardo that begins the chapter on belief systems: "When one paints one should think of nothing: everything then comes better." On the surface, Raphael's assertion seems to suggest that beliefs interfere with art and that art is prerational. But Raphael was one of the most rational artists of the Renaissance. Consider, for example, his great fresco *The School of Athens*—its complex proportion, perspective, and schematization. Raphael's work contradicts a simplistic separation of thinking and doing. It is more likely that Raphael's "non-thinking" was instead a total *integration* of thinking and doing. While he worked, any theory–practice dichotomy disappeared, and any thinking separate from the making of the work ceased to be obvious.

In the early 1990s, the Russian émigré collaborative artists Vitaly Komar and Alexander Melamid, quick to catch on to the ways things work in the United States, got a grant from the Nation Institute to conduct a survey on Americans' attitudes to art. In their poll of 1,001 adults, more than half the respondents preferred expressive brush strokes and soft curves over strokes and shapes that were slick and angular. Blue was the favorite color of 44 percent of the respondents. Outdoor scenes won handily over indoor (88 percent to 5 percent), and wild animals were favored over domestic by a 2-to-1 margin. Landscapes featuring forests and water were the most popular. Twice as many people preferred the figures in their paintings to be at leisure rather than working or posing, and they preferred historical figures from a long time ago over recent figures. Americans apparently prefer large paintings over small paintings. But not too big: 67 percent like paintings the size of

a dishwasher, but only 17 percent prefer them as large as a full-size refrigerator. Realizing they knew their audience (within the polling firm Marttila & Kiley's guaranteed margin of error of 3.2 percent), Komar and Melamid then composed their "perfect" painting: *America's Most Wanted* (1993) (Figure 5.1), the climax of their exhibition "People's Choice: The Polling of America." Melamid, however, commented about the painting: "I must confess it's not the best picture in the world."[3]

While we might agree with Willard Holmes, deputy director of the Whitney Museum, who said that this work would have no influence on future art-making, or with Peter Schjeldahl, art critic for the *Village Voice*, who described the project as silly,[4] the work is not without meaning. Komar and Melamid are working within a multitude of social roles: the artist as intellectual, as craftsman, and as entrepreneur (in both their securing a grant and in creating a marketable commodity). Perhaps most clearly, they are functioning as social critics. When asked by an interviewer whether they were attempting to create "a counter to the official art of America," Melamid replied: "Definitely. That's a totally dissident art. Mostly, of course, because of the question, Who are the viewers? Who is the audience? Nobody asks this question."[5]

And they know their audience, unlike Jacob Epstein in the anecdote that begins the chapter on audience. Epstein put the work up and then, under duress, modified it. Komar and Melamid first acquired their knowledge about their audience and then made the work. Of course, as the chapter goes on to argue, there is a predisposition to suspect such a complete knowledge of one's audience's preferences in making art.

But Komar and Melamid are working with two audiences. There is, obviously, the audience that makes up the cross-section of America, as represented by the 1,001 survey participants. But that audience is more the *subject* of this artwork than the recipient to whom this work is addressed—a fact that is revealed by the condescension implicit in many of the questions. While an audience reasonably close to a demographic cross-section of the country might read about the artwork in the *New York Times Magazine*, the *Chicago Tribune*, or *The Nation*, the group that actually went to go *see* the work at the Alternative Museum in New York was much more select. This group saw three-dimensional graphs the size of human figures, two-dimensional graphs hung on the wall—a whole raft of documentation arranged as an exhibit. What they saw looked like, participated in, and parodied the conventions of conceptual art, which, of course, is the dominant tradition within which this work operates. This work has a sensational appeal to public taste, but that appeal actually confirms that this work is primarily addressed to the art world, in a most puzzlingly ironic way. Like Jeff Koons, who in the epigraph to Chapter 4 announces that he wants to be invited to the White House, Komar and Melamid are playing with scandalous irony, an irony that gives this work its edge—and perhaps a slightly corrosive taste.

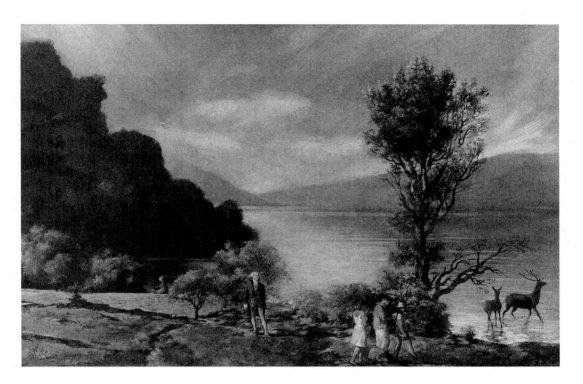

Figure 5.1 Vitaly Komar and Alexander Melamid, *America's Most Wanted,* 1993. Oil and acrylic on canvas, dishwasher size. (Courtesy Ronald Feldman Fine Arts, New York. Photo Credit: D. James Dee.)

In Chapter 1, four hypothetical instructors critiqued a student painting, *Jacob and the Angel*. Each critic brought a different set of beliefs to the work: different theories of art and presuppositions. They also imagined different social functions for the work, each seeing the role of the artist in a somewhat different way, and each behaving as a distinct kind of audience with distinct expectations for the work. In such situations, a more useful approach to this diversity of belief would be to ask, "What do *you* want the work to do?"

Such an approach implies that the key to meaningful discussion within the art world is a willingness to discern the implied beliefs and presuppositions functioning in different artworks and in reactions to artworks. As it is in the creation of artworks, the basis for critical response to artworks is not always as explicit as it first appears; complex systems of belief are involved. Although people as different as Hilton Kramer, Hal Foster, and Jesse Helms give explicit reasons for their attitudes, their attitudes also involve unexamined beliefs about social roles and audiences. When others felt differently, why did Jesse Helms vilify David Wojnarowicz? Why does Hal Foster rhapsodize about Jenny Holzer? And why did Hilton Kramer trash Philip Guston? Knowing the answers to these questions is useful, for those answers are at the center of art-making. They reveal much about artists' diverse social roles, their beliefs, and the function of audiences in realizing those roles and beliefs.

NOTES

1. Nicholas Wolterstorff, *Art in Action* (Grand Rapids, Mich.: Eerdmans, 1980), x.
2. *Baselitz: Paintings 1960–83,* ed. Richard Calvocoressi. (London: Whitechapel Art Gallery, 1983), 65.
3. Quoted in Richard B. Woodward, "The Perfect Painting," *New York Times Magazine,* February 20, 1994, 36.
4. "By Popular Request—Perfection," *Chicago Tribune,* March 27, 1994, section 13, 10–11.
5. "Painting by Numbers: The Search for a People's Art," *Nation,* March 14, 1994, 348.

Works Cited

Adams, Laurel Wood. "Art Press Review." *New Art Examiner*, January 1984, 5.

Apollinaire, Guillaume. *The Cubist Painters: Aesthetic Meditations 1913*, trans. Lionel Abel. Documents of Modern Art. New York: Wittenborn, Schultz, 1949.

———. "Monthly Chronicle." In *Apollinaire on Art: Essays and Reviews 1902–1918*, trans. Susan Suleiman; ed. Leroy C. Breunig, 335–38. The Documents of Twentieth-Century Art. New York: Viking, 1972.

———. "The Douanier." In *Apollinaire on Art: Essays and Reviews 1902–1918*, trans. Susan Suleiman; ed. Leroy C. Breunig, 339–54. New York: Viking, 1972.

Aristotle. *Aristotle's Art of Poetry*. Trans. I. Baywater; ed. W. H. Fyfe. Oxford: Oxford University Press, 1952.

Ashton, Dore, comp. *Picasso On Art: A Selection of Views*. New York: Penguin Books, 1977.

Baselitz: Paintings 1960–83. Richard Calvocoressi, ed. London: Whitechapel Art Gallery, 1983.

Beckmann, Max. "On My Painting." In Robert L. Herbert, *Modern Artists on Art,* 131–37.

Bergman-Carton, Janis. "Like an Artist." *Art in America* 81 (January 1993): 35–37.

Blinderman, Barry. "The Compression of Time: An Interview with David Wojnarowicz." In *David Wojnarowicz: Tongues of Flame,* ed. Barry Blinderman, 49–63. Normal: University Galleries of Illinois State University, 1990.

Boas, George. "Courbet and His Critics." In *Courbet in Perspective,* ed. Petra Ten-Doesschate Chu, 42–52. Englewood Cliffs, N.J.: Prentice-Hall, 1977.

Bramson, Phyllis. Letter. *New Art Examiner* 6 (June 1979): 8.

Brown, Milton W. *The Story of the Armory Show*. New York: Joseph H. Hirshhorn Foundation, 1963.

Buckle, Richard. *Jacob Epstein, Sculptor.* New York: World, 1963.

Clark, Kenneth. "Courbet's Nudes." In *Courbet in Perspective,* ed. Petra Ten-Doesschate Chu, 55–56. Englewood Cliffs, N.J.: Prentice-Hall, 1977.

Clifford, James. "Histories of the Tribal and the Modern," *Art in America* 73 (April 1985): 164–177+.

Cockcroft, Eva. "Abstract Expressionism: Weapon of the Cold War." *Artforum* (June 1974): 39–41.

Cork, Richard. "Overhead Sculpture for the Underground Railway." In *British Sculpture in the Twentieth Century,* ed. Sandy Nairne and Nicholas Serota, 98. London: Whitechapel Art Gallery, 1981, 91–101.

Cotter, Holland. "Agnes Martin: All the Way to Heaven." *Art in America* 81 (April 1993): 88–97+.

Cox, Kenyon. "The 'Modern' Spirit in Art: Some Reflections Inspired by the Recent International Exhibition," *Harper's Weekly*, March 15, 1913. Reprinted in *1913 Armory Show 50th Anniversary Exhibition 1963*, 165–168.

Drier, Deborah. "Cindy Sherman at Metro Pictures." *Art in America* 74 (January 1986): 136–38.

Faunce, Sarah, and Linda Nochlin. *Courbet Reconsidered.* New York: Brooklyn Museum, 1988.

Feldman, Edmund B. *The Artist.* Englewood Cliffs, N.J.: Prentice-Hall, 1982.

Finster, Howard (as told to Tom Patterson). *Howard Finster, Stranger From Another World: Man of Visions Now on this Earth.* New York: Abbeville Press, 1989.

Foster, Hal. "Against Pluralism." In *Recodings: Art, Spectacle, Cultural Politics,* 13–32. Port Townsend, Wash.: Bay Press, 1985.

Frueh, Joanna. "Joy Poe." *New Art Examiner* 6 (June 1979): 8.

Fry, Edward F. *Robert Morris: Works of the Eighties.* Newport Beach, Calif.: Newport Harbor Art Museum, 1986.

Gablik, Suzi. "Deconstructing Aesthetics: Toward a Responsible Art." *New Art Examiner* 16 (January 1989): 32–35.

———. *Has Modernism Failed?* New York: Thames and Hudson, 1984.

Garb, Tamar. "Renoir and the Natural Woman." *Oxford Art Journal* 8, no. 2 (1985): 3–15.

Gardner, Howard. *Frames of Mind: The Theory of Multiple Intelligences.* New York: Basic Books, 1983.

Gash, John. "Rembrandt or Not?" *Art in America* 81 (January 1993): 56–69+.

Goldin, Nan. Interview. *Bomb* 37 (Fall 1991):31.

Gouma-Peterson, Thalia, and Patricia Mathews. "The Feminist Critique of Art History." *Art Bulletin* 69 (September 1987): 326–357.

Graham-Dixon, Andrew. "This is the house that Rachel built," *Independent,* November 2, 1993. Reprinted in Lingwood, *Rachel Whiteread: House,* 134.

Guilbaut, Serge. *How New York Stole the Idea of Modern Art.* Trans. Arthur Goldhammer. Chicago: University of Chicago Press, 1983.

Hauser, Arnold. *The Social History of Art*. London: Routledge & Kegan Paul, 1951.

Hennessy, Richard. "What's All This About Photography?" *Artforum* 17 (May 1979): 22–25.

Herbert, Robert L., ed. *Modern Artists On Art*. Englewood Cliffs, N.J.: Prentice-Hall, 1964.

Herrera, Hayden. *Frida: A Biography of Frida Kahlo*. New York: Harper & Row, 1993.

Hess, Thomas B. *Barnett Newman*. New York: Museum of Modern Art, 1971.

Holmes, Willard. "By Popular Request—Perfection." *Chicago Tribune*, March 27, 1994, section 13, 10–11.

Houskeeper, Barbara. Letter. *New Art Examiner* 6 (June 1979): 9.

Kandinsky, Wassily. "Reminiscences." In Herbert, *Modern Artists on Art*, 19–44.

Klee, Paul. "On Modern Art." In Herbert, *Modern Artists on Art*, 74–91.

Kloster, Ulla. "There's a stoney house!" In Lingwood, *Rachel Whiteread: House*.

Komar, Vitaly, and Alexander Melamid. Interview. "Painting by Numbers: The Search for a People's Art." *Nation*, March 14, 1994, 334–348.

Kramer, Hilton. "A Mandarin Pretending to be a Stumblebum." *New York Times*, October 25, 1970, B27.

Kurtz, Bruce D. *Contemporary Art, 1965–1990*. Englewood Cliffs, N.J.: Prentice-Hall, 1992.

Larson, Kay. "How Should Artists Be Educated?" *Art News* 82 (November 1983): 85–91.

Lingwood, James. *Rachel Whiteread: House*. London: Phaidon, 1995.

Lippard, Lucy R. "Sex and Death and Shock and Schlock: A Long Review of 'The Times Square Show' by Anne Ominous." *Artforum* 19 (October 1980): 50–55.

———. "Trojan Horses: Activist Art and Power." In *Art After Modernism: Rethinking Representation*, ed. Brian Wallis, 341–358. New York: New Museum of Contemporary Art, 1984.

Littlejohn, David. "Who Is Jeff Koons and Why Are People Saying Such Terrible Things About Him?" *Artnews* 92 (April 1993): 90–94.

Martin, Agnes. "Selected Writings." In *Agnes Martin*, ed. Barbara Haskell, 9–31. New York: Abrams, 1992.

McCormick, Carlo. Review of Howard Finster at PaineWebber. *Artforum* 28 (May 1990): 184–185

McEvilley, Thomas. "Doctor Lawyer Indian Chief: '"Primitivism" in 20th Century Art' at the Museum of Modern Art in 1984." *Artforum* (November 1984): 54–61.

McEwen, John. "The house that Rachel built." *Sunday Telegraph*, October 24, 1993. Reprinted in Lingwood, *Rachel Whiteread: House*.

Mellow, James R. *Charmed Circle: Gertrude Stein & Company*. New York: Praeger, 1974.

Morris, Robert. "American Quartet." *Art in America* 69 (December 1981): 92–105.

————. *Continuous Project Altered Daily: The Writings of Robert Morris.* Cambridge: MIT Press, 1993.

Motherwell, Robert, ed. *The Dada Painters and Poets.* Documents of Modern Art. New York: Wittenborn, Schultz, 1951.

Nead, Lynda. "'Pleasing, Cheerful and Pretty?' Sexual and Cultural Politics at the Hayward Gallery." *Oxford Art Journal,* 8 no. 1 (1985): 72–74.

1913 Armory Show 50th Anniversary Exhibition 1963. New York: Henry Street Settlement, 1963.

Nochlin, Linda. "Courbet's *L'origin du monde:* The Origin Without an Original." *October* 37 (1986): 76–86.

Olivier, Fernande. *Picasso and His Friends.* Trans. Jane Miller. New York: Appleton-Century, 1965.

Poe, Joy. Interview. *New Art Examiner* 6 (June 1979): 8.

Raffaele, Joe, and Elizabeth Baker. "The Way-Out West: Interviews with 4 San Francisco Artists." *Art News* 66 (Summer 1967): 38–41+.

Rathje, Pat. Letter. *New Art Examiner* 6 (June 1979): 9.

Robinson, Walter. "Renoir: A Symposium." *Art in America* 74 (March 1986): 102–125.

Rogoff, Irit. "Production Lines." In *Team Spirit,* 33–38. New York: Independent Curators, 1990.

Rose, Barbara. "American Painting: The Eighties." In *Theories of Contemporary Art,* ed. Richard Hertz, 63–77. Englewood Cliffs, N.J.: Prentice-Hall, 1985.

Rosenblum, Robert. "Matisse: A Symposium." *Art in America* 81 (May 1993): 74–87.

————. "Renoir: A Symposium." *Art in America* 74 (March 1986): 102–125.

Rubin, William. "Modernist Primitivism: An Introduction." In*"Primitivism" in 20th-Century Art: Affinity of the Tribal and the Modern,* ed. William Rubin, vol 1, 1–81. New York: Museum of Modern Art, 1984.

Schjeldahl, Peter. "Renoir: A Symposium." *Art in America* 74 (March 1986): 102–125.

Seldes, Lee. *The Legacy of Mark Rothko,* 42–45. New York: Holt, Rinehart and Winston, 1978.

Serra, Richard. *Richard Serra: Interviews, Etc. 1970–1980,* 186. New York: Hudson River Museum, 1980.

Shahn, Ben. *The Shape of Content.* Cambridge: Harvard University Press, 1957.

Shattuck, Roger. *The Banquet Years.* Rev. ed. New York: Random House, 1968.

Shirey, David L. "Impossible Art: What It Is" ('Thinkworks')." *Art in America* 57 (May 1969): 32–47.

"Showdown at 'The West As America' Exhibition." *American Art* 5 (Summer 1991): 2–11.

Siegel, Jeanne. "Hans Haacke: What Makes Art Political." In *Artwords 2: Discourse on the Early 80s,* 63–64. Ann Arbor, Mich.: UMI Research Press, 1988.

———. "Leon Golub: What Makes Art Political." In *Artwords 2: Discourse on the Early 80s,* 53–62. Ann Arbor, Mich.: UMI Research Press, 1988.

Silber, Evelyn. "Introduction." *The Sculpture of Epstein,* 1–61. Lewisburg, Pa.: Bucknell University Press, 1986.

Silber, Evelyn, and Terry Friedman. "Epstein in the Public Eye." In *Jacob Epstein: Sculpture and Drawings,* 208–227. Silber and Friedman, eds. Leeds: W.S. Maney, 1989.

Storr, Robert. *Guston.* New York: Abbeville Press, 1986.

———. "'Tilted Arc' Enemy of the People?" *Art in America* 73 (September 1985): 90–97.

Tidiman, Richard. "When a house is not a home." *East London Advertiser,* October 28, 1993. Reprinted in Lingwood, *Rachel Whiteread: House,* 133.

"Tilted Arc: Hearing." *Artforum* 23 (Summer 1985): 98–99.

Trachtenberg, Alan. "Contesting the West." *Art in America* 79 (September 1991): 118–123+.

Tully, Judd. "The Kahlo Cult." *Artnews* 93 (April 1994): 126–133.

Varnedoe, Kurt. "On the Claims and Critics of the Primitivism Show." *Art in America* 73 (May 1985): 11–13.

Vasari, Giorgio. *Lives of the Most Eminent Painters, Sculptors and Architects.* Trans. Gaston Du C. de Vere. New York: Abrams, 1979.

Wallis, Brian, ed. *Hans Haacke: Unfinished Business.* New York: New Museum of Contemporary Art; Cambridge: MIT, 1986. 118–133.

Wallis, Brian. "Senators Attack Smithsonian Show." *Art in America* 79 (July 1991): 27.

Westfall, Stephen. "The Ballad of Nan Goldin." *Bomb* 37 (Fall 1991): 31.

Wojnarowicz, David. *Close to the Knives: A Memoir of Disintegration.* New York: Random House, 1991.

———. Interview. In Blinderman, *David Wojnarowicz,* 49–63.

Wolterstorff, Nicholas. *Art in Action.* Grand Rapids, Mich.: Eerdmans, 1980.

Woodward, Richard B. "The Perfect Painting." *New York Times Magazine.* (February 20, 1994): 36–37.

Wright, Frank Lloyd. *Architectural Record,* March 1908. Reprinted in *In the Cause of Architecture: Frank Lloyd Wright,* ed. Frederick Guthei, 53–119. New York : McGraw-Hill, 1975.

Index